IMAGES
*of America*

# BIG STONE GAP

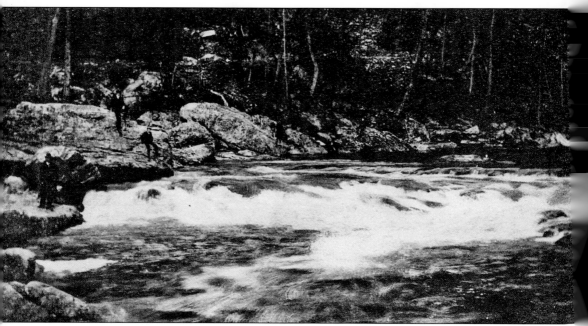

**ROARING FORK OF THE POWELL RIVER.** This branch creates the gap in Stone Mountain. An early name of the town was Three Forks because of the confluence of three branches of the river that merge together at the town. The name Powell River comes from Ambrose Powell, who was in the hunting party of the Thomas Walker expedition. Walker, a physician, explorer, and surveyor, led the first expedition that discovered the Cumberland Gap. (Postcard courtesy of C. F. and Debbie Wright.)

**ON THE COVER:** The Fox residence was a popular gathering place for early families, and tennis parties were frequently held. Present are James Hodge, Belle Slemp, Bettie Churchill, ? Matheson, Mrs. Walter Addison, Laura Slemp, Mary Cummins Bullitt, Rufus Ayers, Joseph Kelly, Francis Harrington, Julia Hardin, Janie Slemp, French Kunkel, Lyle Irvine, Mrs. Joshua Bullitt, Mrs. Joseph Kelly, Tate Irvine, Elizabeth Fox, and Minnie Fox. (Photograph courtesy of Garnett Gilliam.)

IMAGES
*of America*

# BIG STONE GAP

Sharon B. Ewing
Foreword by Adriana Trigiani

ARCADIA
PUBLISHING

Published by Arcadia Publishing
Charleston, South Carolina

Printed in the United States of America

Library of Congress Catalog Card Number: 2007943006

For all general information contact Arcadia Publishing at:
Telephone 843-853-2070
Fax 843-853-0044
E-mail sales@arcadiapublishing.com
For customer service and orders:
Toll-Free 1-888-313-2665

Visit us on the Internet at www.arcadiapublishing.com

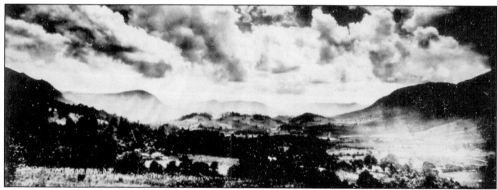

POWELL VALLEY, C. 1900. In 1912, John Fox Jr. described the head of Powell Valley as follows: "Powell's Mountain here runs its mighty ribs into the Cumberland range with such humiliating violence that Cumberland, turned feet over head by shock, has meekly suffered somebody to dub it plain Stone Mountain . . . At the point of contact . . . Powell's Valley starts on its rolling way to the south. Ten miles below, Roaring Fork has worn down to water level, a wild cleft through Stone Mountain and into the valley. On the other side, South Fork drops 700 feet of waterfalls from Thunderstruck Knob, and the two streams sweep towards each other like the neck of a lute and . . . curve away . . . to come together at last and bear the noble melody of the Powell's River down the valley. The neck is not over 200 yards wide, and, in the heart . . . is the town . . . All this—cleft, river, and town—is known far and wide as 'The Gap.'" (Photograph courtesy of Southwest Virginia Museum.)

# CONTENTS

# ACKNOWLEDGMENTS

This book was greatly contributed to by Garnett Gilliam and was supported in several ways by C. F. and Debbie Wright. I had a great editorial team in Dr. Lawrence Fleenor, C. F. Wright, Dr. B. E. Polly Jr., and Brooksi Hudson with Arcadia Publishing.

I appreciate those who opened their homes to me and answered my many questions. They include Brownie and Barbara Polly, Randall and Viola Simpson, William and Judy Cole, and Nannie Bellamy. I am also indebted to author Adriana Trigiani for graciously writing the foreword to the book and for her continued support of Big Stone Gap.

I would like to acknowledge other community historians, writers, and photographers, past and present, who have done so much to preserve the community's history and stories. They include John Fox Jr., George Jenkins, C. Bascom Slemp, Janie Slemp Newman, Gilbert Knight, James Robinette, Morris Burchette, Clara Lou Kelly, Carl Knight, Luther Addington, Emory Hamilton, James Taylor Adams, Buck Henson, Bill Hendrick, Don Wax, Talmadge Warren, and George Dalton. Finally, I would like to thank Anthony Ewing for his tireless support in all our mutual endeavors.

All royalties from this book will be donated to the Friends of the Southwest Virginia Museum Historical State Park to assist in their goals to preserve and promote the museum. The Friends of the Museum is a citizens support organization. The group invites you to become a part of its efforts.

A final thought: this volume presents a collection of images that strive to tell the many stories of Big Stone Gap. Every attempt was made to portray a broad section of interesting photographs and historical information; however, the author acknowledges that there will always be more stories to tell.

# FOREWORD

Once upon a time, long, long ago, three forks of the mighty Powell River surged through the Cumberland Mountains to create a glorious valley. Nestled in the far southwestern corner of Virginia, the valley became a place called Big Stone Gap. My hometown has always been a wonderful place to visit and, for those of us raised there, a great place to live.

Lush forests and rambling hills that lie at the feet of never-ending green mountains became the setting of John Fox Jr.'s novel, *The Trail of the Lonesome Pine*; the boyhood home of Virginia governor Linwood Holton; and the inspiration for countless poems, songs, plays, and books that attempt to describe the wonder of this one-of-a-kind town.

In this pictorial history, you will visit the distant past, more than a century ago, as well as the recent past in Big Stone Gap. You will experience the confluence of elements that make our town special. You will visit the birthplace of football stars, the Jones brothers, and will see for yourselves how this mountain town was its own brand of dream factory.

Doctors, railroad men, public servants, coal miners, company men, architects, athletes, mothers, fathers, teachers, farmers, seamstresses, soldiers, writers, singers, musicians, and quilters—just to name a few—define the Big Stone Gap experience with their courage, intellectual prowess, talent, and craftsmanship. Folks with diverse backgrounds, of Scots Irish, German, African American, and Melungeon descent, and a patchwork quilt of immigrants from Europe, the Middle East, and the Philippines have made their homes here.

Big Stone Gap is a slice of authentic Americana, mountain style. The stories told in photographs and prose on these pages are the stories of small-town America, preserved with wit, hospitality, old-fashioned elegance, a love of art, and a keen sense of community.

Holding the artifacts and history of Big Stone Gap, the Southwest Virginia Museum sits atop Poplar Hill with a bird's-eye view of the main street below and is surrounded by 1890s Victorian homes, wide open fields, gardens, and air so fresh you wish you could bottle it. The museum is the heart of the town, the gathering place for special events and annual holiday celebrations like the Festival of Trees.

When I was a girl, we often took a walk to the museum on rainy days. The curator, James True, was always happy to show us through and let us linger over the dioramas and displays, seemingly for hours. My favorite item in the museum was the guest book where I would see names and addresses of people from all over the world who had heard of Big Stone Gap or had by chance wandered through town and stopped in for a visit. At the time, it seemed the names in the book had a certain power. Somehow, of all of the places in the world, we had been discovered. This seemed magical to me.

Now readers can take a tour of Big Stone Gap's history in this wonderful book. You may see someone you know on these pages or maybe someone you've heard about, or maybe this will be your first visit to Big Stone Gap. With any luck, you won't be a stranger for long. Big Stone Gap is a place that can fill you with longing, and when you go, it will stay with you. The same goes for this book, pages filled with images and stories we can return to time and time again that tell the story of this special place we call home.

—Adriana Trigiani

# INTRODUCTION

Native Americans such as the Cherokees, Iroquois, Wyandottes, and Shawnees found the area of present-day Southwest Virginia a hunter's paradise. Game such as elk, turkey, deer, bear, and buffalo were abundant. The 18th century saw the arrival of early hunters and explorers such as Dr. Thomas Walker, Ambrose Powell, Elisha Walden, and Daniel Boone. They too found a hunter's paradise, but more importantly, they discovered new pathways to access the lands westward.

Clashes between the British and the French over the interior of the American continent led the British to pour settlers into Southwest Virginia. The purposes were to push the French back and serve as a protective barrier from Native American attacks on Eastern settlements. Many of these settlers were religious dissenters or populations whom the English considered troublesome. Primary nationalities included the Scots Irish and Germans. In addition, the area was being populated by Melungeons. In 1750, Christopher Gist was the first recorded white man in present-day Wise County.

Three Forks, the earliest recorded name for Big Stone Gap, soon became a thoroughfare for early pioneer trails in the region. It was a connecting point from the Holston Settlements to the Shawnee Country in Ohio. Sometime in his travels, Daniel Boone shot a bear on the banks of the Powell River at Three Forks. He recorded the bear killing by carving it in a beech tree. Later pioneers recalled seeing the standing tree.

An early settler at the forks of the Powell River was John Jameson, who received a land grant in 1793. Lee County was formed from Washington County with the community of Three Forks being the dividing line with Russell County that same year. The Three Forks Primitive Baptist Church was formed in 1798. Later the church organized a congregation in Powell's Valley at the Jones School House. This became the first area school and was later called the Buffalo Academy.

In 1802, John Gilley bought 100 acres in Wildcat Valley from George and Kathy Barger. Later this and additional land John owned passed to his grandson, Elkanah Gilley. The Gilley farm in the center of Three Forks consisted of approximately 60 acres with established businesses. Elkanah was one of the landowners who sold property to form the town of Big Stone Gap.

Wise County was formed in 1856, and Three Forks became a part of the new county. Another Three Forks landowner, William Richmond, owned the property along present-day Aviation Road to Cadet, and north to Roaring Branch. William was the first justice of the Wise County Court, and the Richmond District, which contained Big Stone Gap, got its name from him. After the Civil War, the farm passed to the Flanary family. James Monroe Flanary owned more than 100 acres and was another of the landowners who sold property to form the town.

Nelson Horton owned property on the western end of Three Forks, where he also had established businesses. He too owned a mill and a store. Horton was the third landowner who sold property for the establishment of the town.

During the early 1800s, as other pioneers became established in Southwest Virginia, socioeconomic divisions began to emerge. Valley bottom–dwelling families tended to own some slaves in small numbers, while mountaineers who lived along the ridge tops tended to be non-slave owners. This led to bitter divisions along geographic lines during the Civil War; many of the mountaineers were pro-Union. Three Forks itself became a mustering center for Company A of the 51st Regiment Virginia Volunteer Infantry.

The divisions continued after the war and paralyzed county government, family structure, and the community. Some African Americans left the region while others adopted family surnames and farmed or obtained jobs in households. Families, both black and white, experienced the bushwhacking times, as they are referred to; a time plagued with unlawfulness, thievery, and vengeance murders. Much of this took on the modern characterization of clan feuds. It is against this backdrop that iron ore and, later, coal were discovered, which sent the community of Three Forks into development frenzy.

During the 1870s, much was published about the mineral and timber resources of the Appalachian Mountains. Gen. John Daniel Imboden, a former Confederate officer, published *Coal and Iron Resources of Virginia* in 1872. General Imboden focused on Three Forks as the location for industrial development. In Pittsburgh, Pennsylvania, Imboden gave a speech to industrialists about the potential of the area as the new "Pittsburgh of the South." Found in the gap of Stone Mountain were all the ingredients for the production of iron: limestone, coal, and iron ore. This presentation led to avid interest by Northern investors.

In 1880, Imboden purchased 47,000 acres of Wise County land and a one-sixth interest in another 100,000 acres. It is reported that Imboden never paid more than $1 an acre and had once purchased more than 21,000 acres for 35¢ per acre. The Three Forks farmland belonging to the Gilleys, Hortons, and Flanarys was purchased for $25 per acre by Henry Clay McDowell of Lexington, Kentucky, and N. B. and H. Clinton Wood of Estiville (Gate City), Virginia. The town, which was now being called Mineral City, was incorporated as Big Stone Gap by an act of the general assembly in 1882. Kentucky geologist John Proctor published a pamphlet detailing 10 reasons why Big Stone Gap was "destined to become a great city." This pamphlet, along with the advertisement of the coming of the railroad, caused investors to flock to Big Stone Gap.

Among them were the Kentucky bluegrass and Virginia investors, who were mainly "in residence" and had much to lose, and the Northern investors with more of a passive interest and less at stake. Early in the town's development, promoters realized that the town had to have "in residence" developers—developers living near their investments—to make progress.

One such "in residence" developer was Rufus Ayers. A native of Southwest Virginia, Ayers amassed wealth as a lawyer and land speculator. He built his house, raised his family, and was an industrialist who was personally involved with Big Stone Gap. Another "in residence" developer was John Fox Jr. and the entire Fox family, who moved from Kentucky to Big Stone Gap in the 1880s. The Slemps, from nearby Turkey Cove, also became instrumental in the development of Big Stone Gap. Others, like the Goodloe brothers, Henry Clay McDowell, and the Wood brothers, played key roles in the town's development.

The promoters of Big Stone Gap had high hopes for the town. They planned for iron furnaces, railroads, an interstate railroad tunnel, a grand hotel, a large park and resort, and much more. The town boomed during the period of 1888–1891. Articles espousing unbridled optimism appeared in the *Post* newspaper. The iron furnaces, along with planning mills and other businesses, sprang up in the gap. The South Atlantic and Ohio Railway and the Louisville and Nashville Railroad brought trains to the outskirts of town. However many undeveloped lots remained in the town and over-speculation was rampant. This led to a series of economic crashes, or busts.

The biggest bust occurred when English capitalists, who had invested heavily in nearby Cumberland Gap and some in Big Stone Gap, stopped investing in railroads, furnaces, and other enterprises being developed throughout the region. Many Northern speculators withdrew their money and headed home as the railroads made Norton, not Big Stone Gap, their terminus. Neither the grand hotel nor the interstate tunnel was ever built. The iron furnace closed for a time, and the bank failed.

Attitudes toward the future of Big Stone Gap fluctuated. Many residents blamed absentee investors for the crash. However optimism still remained the prevailing outlook. In 1900, another boom occurred, but it was much smaller than the one of 1890. The iron furnace reopened, and the Virginia Coal and Iron Company began opening coal mines and constructing coal camps.

New developers arrived with names like Wentz, Taggart, and Leisenring. Additionally, many new laborers arrived to the area.

The new labor force consisted of European immigrants such as Hungarians, Poles, Italians, and Irish. In addition, a number of African Americans from the South came into the coalfields to work in the mining, timber, and railroad industries. These workers formed the backbone of the coal industry and left lasting legacies not only in Big Stone Gap, but also throughout the Appalachian coalfields. The 1900 census and marriage records indicate that Big Stone Gap housed many more miners and laborers than it did bankers, lawyers, and merchants. Today the descendents of miners and laborers form much of the basis of the area's population.

The development of the businesses brought changes in other aspects of the community. Additional churches opened with congregations of Baptist, Methodist, and Episcopalians. The town also organized a public school because the private Stonega Academy was not adequate to educate a growing population. Social and recreational activities abounded with many clubs, music groups, outdoor activities, and parties. An active African American community also existed by 1900. Two black churches and a black school existed, and the African American community members organized their own sports teams and social gatherings.

Several factors shaped Big Stone Gap over the next decades. One was the Great Depression, during which banks failed, developers lost investments, construction stopped, and many miners lost their jobs. Part of President Roosevelt's New Deal was to create jobs for the jobless in America. Some of the Works Progress Administration (WPA) projects included the Civilian Conservation Corp camp in the southern section of town and the WPA art galley in the Big Stone Gap School.

Beginning in the 1890s, the impacts of Virginia Coal and Iron Company and Stonega Coke and Coal, the precursors of Penn Virginia and Westmoreland Coal Company, were tremendous. The corporate office of Stonega/Westmoreland was a familiar landmark in downtown Big Stone Gap, and thousands of miners were on the payroll for many years. Today regional coal operators own many of the former Westmoreland mines. The cyclical nature of coal mining continues as it has during the past 100 years.

Another impact was the passing of C. Bascom Slemp. In his will, Slemp left an endowed foundation to support the "health and education" of the citizens of Lee and Wise Counties. He laid the foundation for the formation of a museum and support of education for area youth, as well as libraries and other civic endeavors. To date, the Slemp Foundation has given millions of dollars to the community of Big Stone Gap.

In the 1950s, consolidation of schools joined the communities of Big Stone Gap and East Stone Gap under the umbrella of the new Powell Valley High School. Education was further expanded by integration in the 1960s, bringing Bland High School into Powell Valley High School. The Powell Valley Vikings are strong in academics and the arts, and are extremely competitive in the field of sports.

Finally, Big Stone Gap was shaped by the founding of two institutions in the later part of the 20th century: Lonesome Pine Hospital and Mountain Empire Community College. The hospital was incorporated in 1967 and was opened in 1973. The groundbreaking for the community college was held in October 1971, with Dr. George B. Vaughan as the first president. The first classes were held in 1972. Education and health care were substantially improved due to these two institutions.

Today the streets of Big Stone Gap are still laid out the way developers designed them in the 1880s. The town still maintains many of its religious and cultural traditions. John Fox Jr. is immortalized in the state's outdoor drama, *The Trail of the Lonesome Pine*. In addition to Fox, the town has produced the private secretary to Pres. Calvin Coolidge, a governor of Virginia, numerous artisans and musicians, a Grammy-winning recording studio, two NFL running backs, and a bestselling 21st-century author. Perhaps most importantly, it has produced a population that values volunteerism, school and community pride, and a great love of history that is preserved through its many museums and historic sites.

# One

# THE BIRTH
# AND THE BOOM

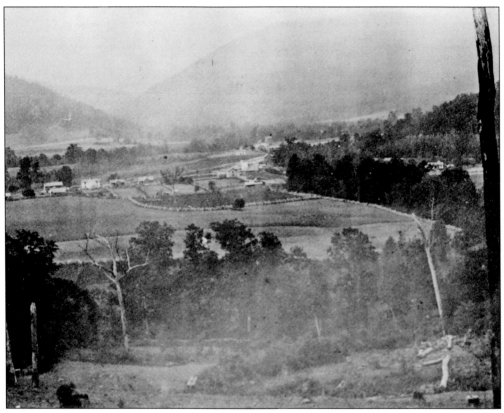

**EARLY VIEW OF THE GAP, 1870S.** The town was later officially established on land owned by three families: the Gilleys, the Hortons, and the Flanarys. Elkanah Gilley owned the land that is now the center of town. H. Nelson Horton owned the property farther down the river, and J. Monroe Flanary owned the land on the north side of the Powell River. (Photograph courtesy of Garnett Gilliam.)

**GRISTMILL ON THE POWELL RIVER.** Elkanah Gilley owned a combination gristmill and sawmill, and a country store near the present-day Country Boy Motel. He was also the first postmaster at the post office, which was located in his store. (Photograph courtesy of Southwest Virginia Museum.)

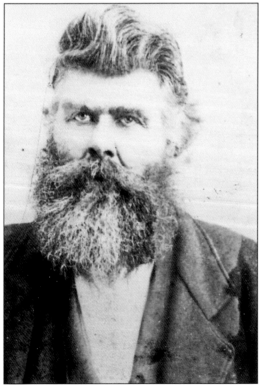

**JAMES MONROE FLANARY.** An early farmer, J. M. Flanary owned more than 100 acres on which he had a variety of livestock and planted corn, beans, potatoes, and sorghum. He also operated a small store on his farm. Flanary died in 1915. The Flanary house (the old Richmond home) was burned by vandals in recent years. (Photograph courtesy of Southwest Virginia Museum.)

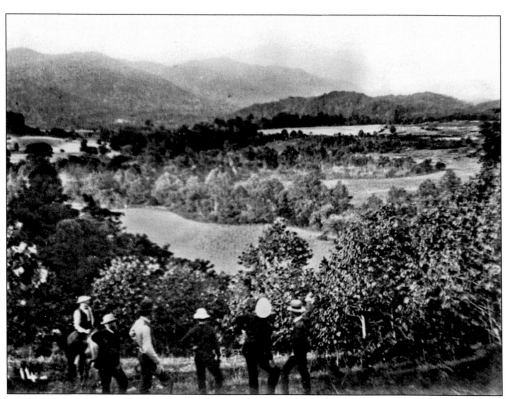

**A VIEW FROM HORTON HILL.**
H. N. Horton also operated a
gristmill. The mill was equipped
mechanically to card wool, which
could then be used for spinning
yarn. In later years, this became
more of a commercial operation and
was called Powell's River Woolen
Mills. After Horton sold his land
to the Big Stone Gap Improvement
Company in 1888, he moved to
upper Lee County. (Photograph
courtesy of Garnett Gilliam.)

**JOHN DANIEL IMBODEN, 1890s.**
Imboden helped promote the
ideal of Big Stone Gap as the
"new Pittsburgh of the South" and
persistently persuaded Northern
capitalists to invest in the region.
In the 1880s, he became a land
agent for the Tinsalia Coal
and Iron Company and bought
thousands of acres in Southwest
Virginia. (Photograph courtesy of
Southwest Virginia Museum.)

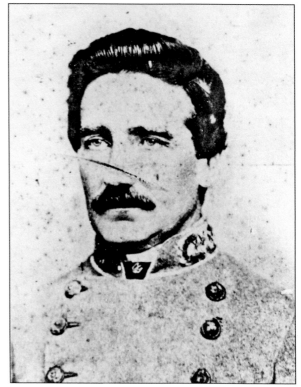

**PEARL MORRIS.** Born in 1862, pioneer Pearl Morris was a rugged individual known for his uncanny ability to find coal. In 1910, he went to work for the Stonega Coke and Coal Company and often went prospecting with geologist James Hodge. It was said that Uncle Pearl, as he was known, could instinctively sniff out coal faster than the coal companies could use their instruments to find it. (Photograph courtesy of Southwest Virginia Museum.)

**RUFUS AYERS.** Attorney General Ayers started many of the early corporations. A few include the Big Stone Gap and Powell Valley Railroad, the Appalachia Steel and Iron Company, and the Big Stone Gap Improvement Corporation. He practiced law, was the first manager of the Virginia Coal and Iron Company, and chartered the South Atlantic and Ohio Railroad Company to lay tracks to the town. (Photograph courtesy of Southwest Virginia Museum.)

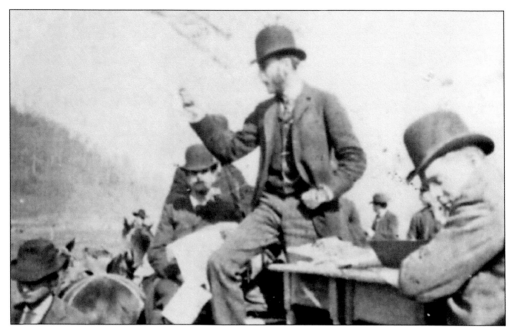

HENRY MCDOWELL SELLING LOTS, C. 1890. McDowell, along with the Wood brothers of Estiville, purchased the Three Forks farmland. The Gilleys, Hortons, and Flanarys' land, which was purchased for $25 per acre, was sold by the lot for more than $1,000 a piece. (Photograph courtesy of Garnett Gilliam.)

EARLY BUSINESSMEN. Many of the first developers came from the bluegrass region of Kentucky and Eastern Virginia. Pictured here are the following individuals, listed from left to right: (first row) W. E. Addison, R. S. Carter, Howard Bullitt, and G. W. Lovell; (second row) Dr. ? Howard, ? Pleasants, William McDowell, judge ? Maury, and Dr. W. C. Shelton. (Photograph courtesy of Southwest Virginia Museum.)

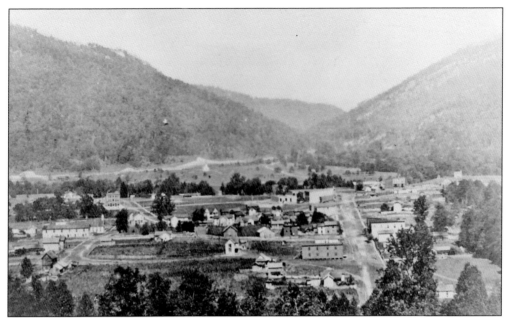

**VIEW OF EARLY BIG STONE GAP.** Several landmarks are visible as the town develops. East Fifth Street and Wood Avenue are definite paths. Left of the center of the photograph is the Intermont Hotel. Also visible is Elkanah Gilley's cabin in the far right of the photograph. The cabin was located approximately at the present-day Food City. One constant is the gap in Little Stone Mountain. (Photograph courtesy of C. F. and Debbie Wright.)

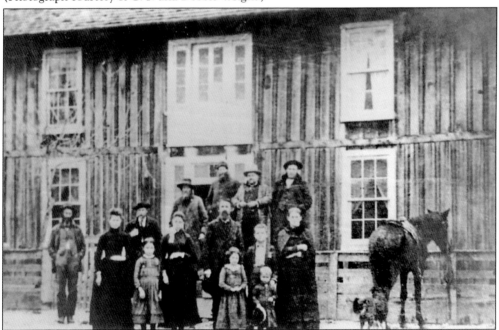

**CENTRAL HOTEL, 1880s.** Built in 1881 by Jerome Duff, the Central Hotel was located at the corner of Jerome Street and Clinton Avenue. The hotel was built of lumber, sawn on-site with a steam sawmill. It was later sold to W. H. Horton and George Brown, who were the owners when it burned on June 29, 1893. (Photograph courtesy of Garnett Gilliam.)

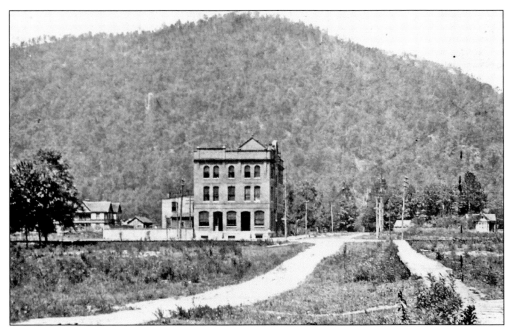

EARLY BUSINESS, 1880S. The town's streets are little more than dirt paths. The Intermont Hotel looms prominently as one of the early businesses. The hotel was certified by a Dr. Kunkel to be in "as clean and healthful condition as is possible under our system of sewerage." (Photograph courtesy of Southwest Virginia Museum.)

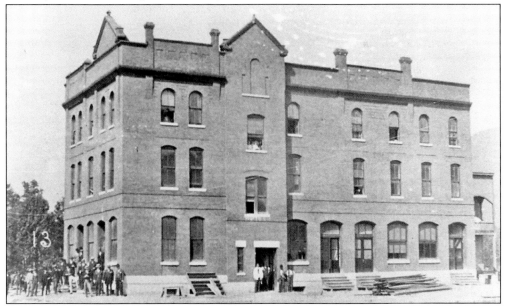

INTERMONT HOTEL, 1890S. Maj. W. C. Harrington operated the hotel. Other small businesses were located on the ground floor, including a barbershop owned by African American businessman Martin Luther. Later the building housed several businesses, including the First National Bank and the original offices of the Southwest Insurance Agency. The town's jail was also in the basement at one point. The building was torn down in 1973. (Photograph courtesy of Southwest Virginia Museum.)

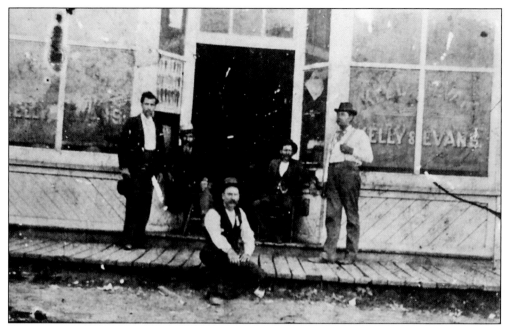

KELLY AND EVANS, 1880S. An early mercantile was owned by C. W. Evans and Mathias Kelly. The store offered a broad array of goods, including notions, dry goods, clothing, a full line of furniture, drugs and patent medicines, ready-mixed paints, oils, and the best brands of tobacco and cigars on the market. Kelly and Evans was located on Wyandotte Avenue. (Photograph courtesy of Southwest Virginia Museum.)

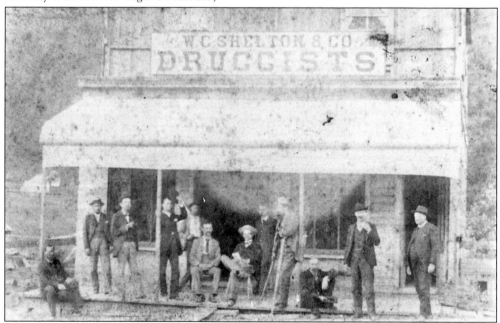

SHELTON DRUGSTORE, 1880S. Men gather outside Dr. W. C. Shelton's drugstore. The business dealt in toilet articles, stationery, fancy candles, mineral water, and tobacco and cigars. Drug prescriptions were considered their specialty. Other early drugstores included Jennings Drug Store, Gilmer Drug Company, and Kelly Drug. (Photograph courtesy of Southwest Virginia Museum.)

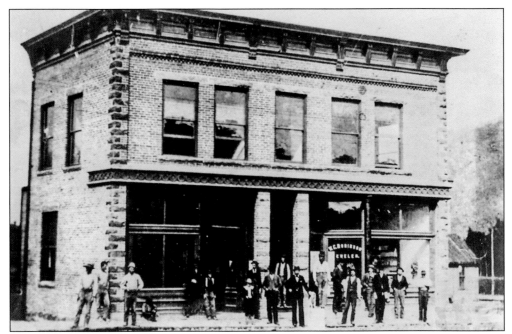

**W. C. ROBINSON JEWELERS, 1880S.** The jeweler carried a handsome line of watches and jewelry with styles and prices to suit everybody. Also the post office was in the building, and Robinson served as postmaster from 1893 to 1897. Robinson was something of an inventor and patented a holder for the stamp pad. After serving as postmaster, he ran the W. C. Robinson Insurance Agency. (Photograph courtesy of Southwest Virginia Museum.)

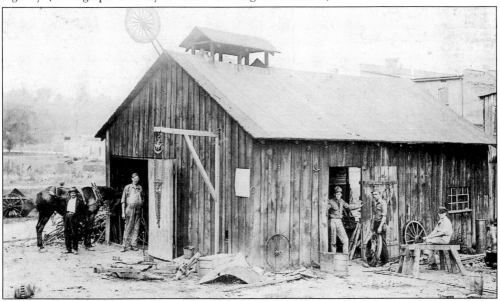

**S. S. MASTERS AND COMPANY.** The early blacksmiths included Rush Cormack, "Pap" Evans, Dick Cawood, James Cox, and Rufe Livesay. Sherman Masters's blacksmith shop was located on the corner of East Fourth Street and Clinton Avenue, near the present-day location of the ABC Store. The young boy on the sawhorses is Harry Masters, and Sherman Masters is the tall man at the left end of the building. (Photograph courtesy of Garnett Gilliam.)

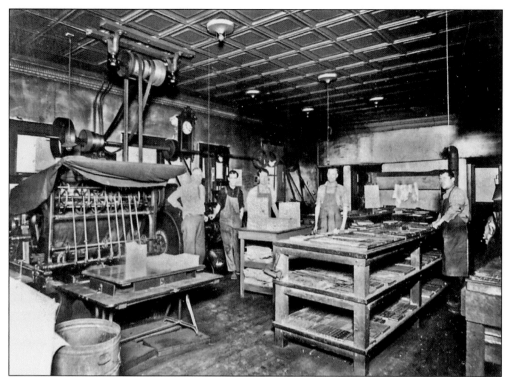

PRINTING THE *POST*. Charles Sears started the town's oldest business, the *Post* newspaper, in 1890. He was president of the Commerce Club and is quoted as saying, "Big Stone Gap. Seat of Empire! Such will it be unless an earthquake swallows it." Editors who followed include C. P. Harris, Harry Ayers, Gilbert Knight, John H. Larry, Carl Knight, Bill Hendrick, Jeff Moore, and Ida Holyfield. (Photograph courtesy of Southwest Virginia Museum.)

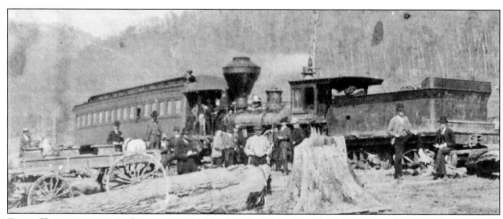

FIRST TRAIN INTO THE GAP, C. 1891. The South Atlantic and Ohio Railroad (SA&O) completed a trial train run into Big Stone Gap on February 22, 1891, from Bristol. The first official run was two days later. The SA&O depot was located in the southern section of town. The first Louisville and Nashville train reached Big Stone Gap on April 15, 1891, with a depot in Cadet. (Photograph courtesy of Garnett Gilliam.)

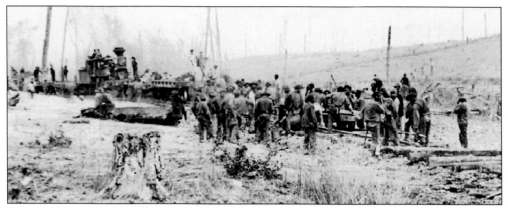

LAYING TRACKS, 1890S. Money to be made during the boom had speculation running high. A total of 12 different railroad lines were surveyed into the gap, as well as a proposed plan to build a "great interstate tunnel" through Black Mountain. The tunnel was to connect Eastern Kentucky with the town, but it was derailed when the boom busted, as recessions began in 1893. (Photograph courtesy of Garnett Gilliam.)

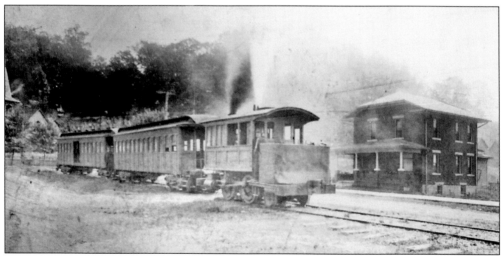

THE DUMMY LINE, 1890S. Built by Rufus Ayers in 1893, the Big Stone Gap and Powell Valley Railroad ran between the South Atlantic and Ohio railway depot in the southern section of town to the Louisville and Nashville depot in Cadet. The term "dummy line" refers to the fact that the train ran within the town between the two depots, functioning almost like a trolley. The train transported people between the depots and throughout town. It also delivered freight to merchants, and children rode the line to and from school. (Photograph courtesy of Garnett Gilliam.)

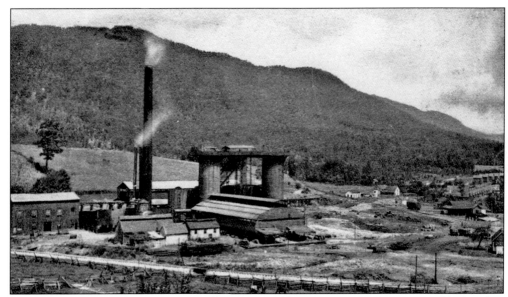

**IRON FURNACE.** Developers first thought iron would bring prosperity. It was mined by hand in 1892 from Wallen's Ridge. Miners supplied their own tools and were paid $1 per day. The iron was initially shipped away. In 1902, Ayers built a furnace that was operated by the Union Iron and Steel Company. The iron was brought by narrow-gauge railroad to the furnace. (Photograph courtesy of Garnett Gilliam.)

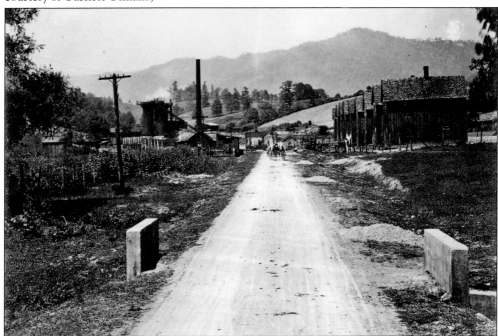

**IRON FURNACE TENEMENT HOUSES, 1900s.** The iron furnace was located in the southern section of town at the end of East Shawnee Avenue. The furnace property consisted of about 45 acres of land and 40 town lots upon which tenement houses were erected. These tenement houses were living quarters for immigrant laborers who worked at the furnace. (Photograph courtesy of Garnett Gilliam.)

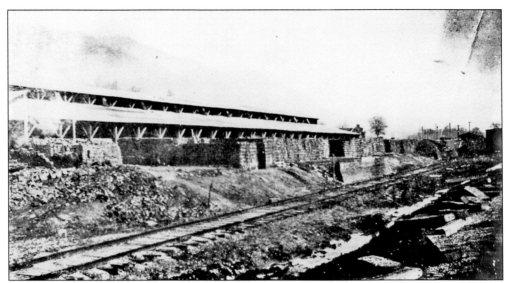

**BRICK FACTORY.** Located in the present-day industrial park, the brick plant was one of the projects of the Big Stone Gap Improvement Committee. Rufus Ayers was the committee's organizer and president. The bricks were promoted as being some of the finest clay in Southwest Virginia, and the plant's capacity was 40,000 bricks per day. (Photograph courtesy of Garnett Gilliam.)

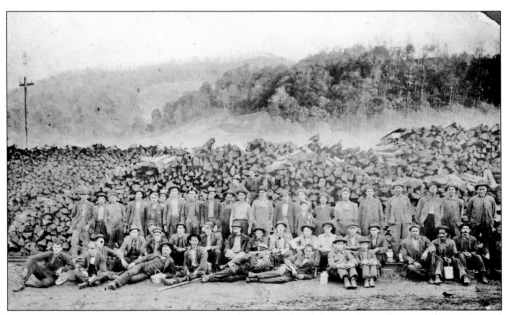

**McCORKLE LUMBER COMPANY.** Quality timber, including black walnut, cherry, oak, maple, and other species, readily caught the attention of corporate lumber companies. In 1897, the McCorkle Lumber Company bought 2,000 acres in Powell Valley. The company built a mill, commissary, and company houses in the southern section of town along present-day Twenty-second Street. (Photograph courtesy of C. F. and Debbie Wright.)

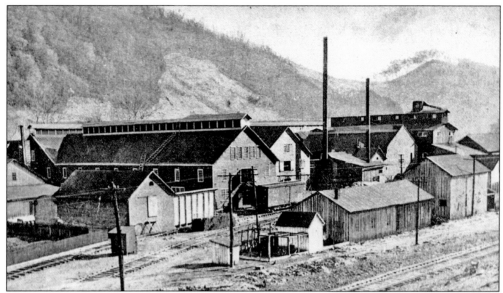

TANNERY, 1890s. In 1898, Ayers opened a tannery that used chestnut, oak, and hemlock to make extract and tan cow hides. It was sold to the United States Leather Company in 1903. The hide tanning ceased in the mid-1920s, but the extract plant continued until the 1930s. Goodloe Brothers Lumber, McCorkle Lumber, and the Tug River Lumber Company supplied the bark. (Photograph courtesy of C. F. and Debbie Wright.)

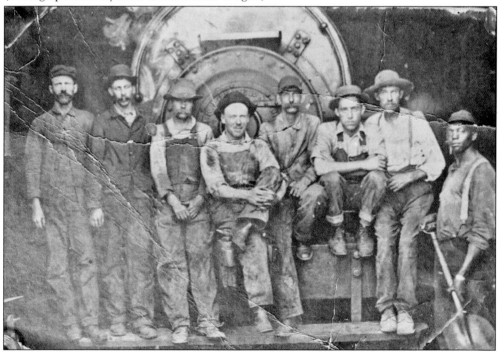

EXTRACT WORKERS. The tannery and extract plant employed hundreds of men during peak season. Pictured, from left to right, are extract workers John Chandler, John Bentley, Charlie Lane, three unidentified, Ed Tomilson, and another unidentified worker. (Photograph courtesy of Garnett Gilliam.)

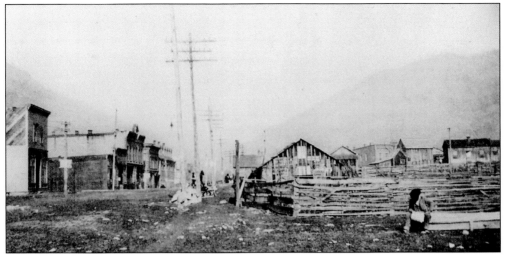

EAST FIFTH STREET, 1890s. John, Ed, and William Goodloe were among the first businessmen. Their livery stable is the building in the right of the picture. They had the best rigs, double or single, in the town. The Goodloe Brothers Store was located down the street on the left. The store offered various goods, including novelty dress goods of ginghams, gossamers, and sateen. (Photograph courtesy of Garnett Gilliam.)

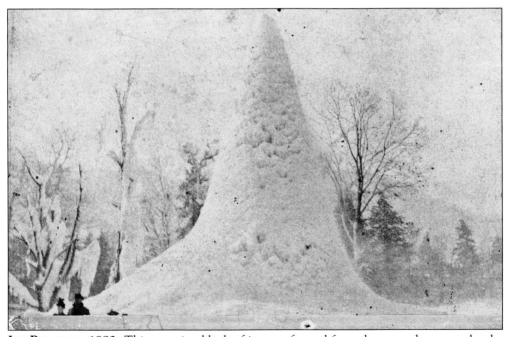

ICE PYRAMID, 1893. This towering block of ice was formed from the spray thrown up by the waterworks fountain downtown. The cone appeared in the extreme January temperatures of 1893 and was approximately 80 feet high. The Glamorgan Iron Company of Lynchburg constructed the system of waterworks around 1890. The first building supplied with water was the Intermont Hotel. (Photograph courtesy of Southwest Virginia Museum.)

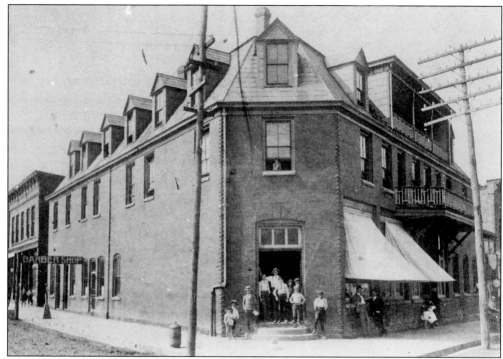

HOTEL EUGENE. On the corner of East Fifth Street and Wood Avenue, this hotel was the predecessor of the Monte Vista. Today it is Miners' Park. The Hotel Eugene was built by R. L. Brown and was named for his son. A room was $2 per day. In 1906, the hotel was sold to brothers James and H. A. W. Skeens. The hotel burned in a 1908 fire. (Photograph courtesy of C. F. and Debbie Wright.)

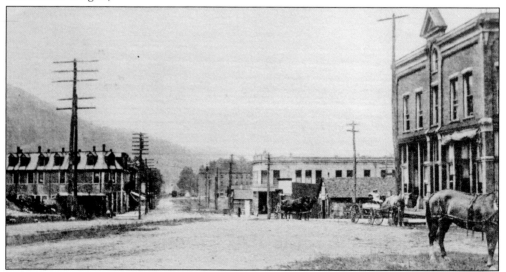

WOOD AVENUE, C. 1900. On the left is the Hotel Eugene, and on the right is the Nickels building, the oldest business structure still in use today as Powell Valley Builders. Nickels sold clothing, furniture, dry goods, and groceries. The store touted cheap prices: flour cost $3 per 100 pounds, salt cost 99¢ per 150 pounds, and coal oil cost 15¢ per gallon. (Photograph courtesy of C. F. and Debbie Wright.)

# Two

# ON THE TRAIL OF THE LONESOME PINE

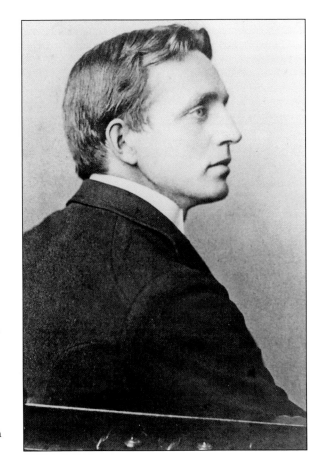

JOHN FOX JR. Born in Kentucky, Fox graduated from Harvard and worked for the *New York Times.* Health issues brought John home, and coal interests brought the Foxes to "The Gap" in 1887. John wrote about his experiences, producing more than 12 novels and 45 short stories, and became the most popular American novelist of his time. He published *The Trail of the Lonesome Pine* in 1908. (Photograph courtesy of Garnett Gilliam.)

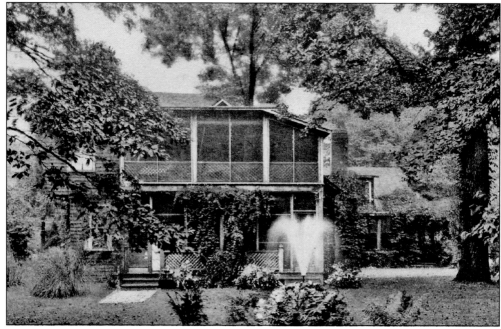

FOX RESIDENCE, 1800S. Located on Shawnee Avenue, the Fox residence was built over a period of several years. As was common of the time, the extended family resided there. Family members heavily participated in the corporate growth of the boom and lost financially during the bust. Today the residence is operated as a historic site and is available for touring. (Postcard courtesy of C. F. and Debbie Wright.)

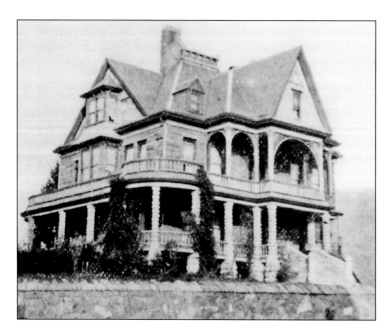

AYERS MANSION, 1890S. Began in 1888 and completed in 1895, this was the home of area developer Rufus Ayers. A prominent structure on Poplar Hill, it is built with native sandstone and limestone cut from nearby Little Stone Mountain. The interior is red oak, sawn locally. Today this home is the Southwest Virginia Museum Historical State Park. (Photograph courtesy of Garnett Gilliam.)

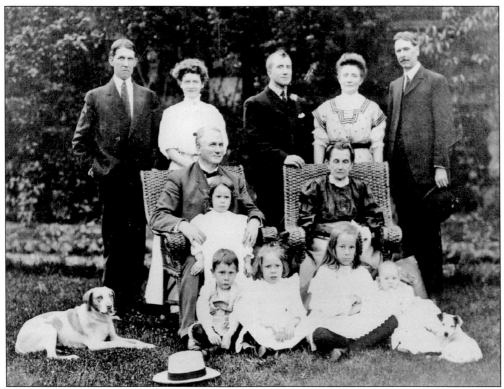

**AYERS FAMILY.** In this 1907 photograph of the Ayers family, pictured are the following: (seated) Adelaide Petit, Rufus Ayers, Kate Lewis Pettit, Rufus Pettit, Victorian Morison Ayers, and Margaret Pettit; (standing) Julia Bullitt Ayers, James Buchanan Ayers, Kate Lewis Ayers Pettit, Vera Pettit (baby), Leonard Overton Pettit, and Harry J. Ayers. (Photograph courtesy of Southwest Virginia Museum.)

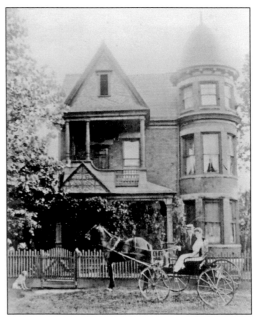

**JAMES AND JULIA BULLITT AYERS.** Pictured is the home of James Ayers and his new bride, Julia Bullitt Ayers. James was the son of Rufus Ayers, and Julia was the daughter of Joshua Bullitt. Today this home still stands on West Second Street. (Photograph courtesy of Southwest Virginia Museum.)

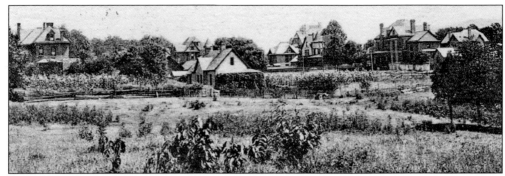

**POPLAR HILL.** This area of town is where most of the coal investors and businessmen built their homes. The land was desirable because much of the surrounding land was marshier due to the nearby Powell River. Several of the early Victorian homes are visible. (Photograph courtesy of C. F. and Debbie Wright.)

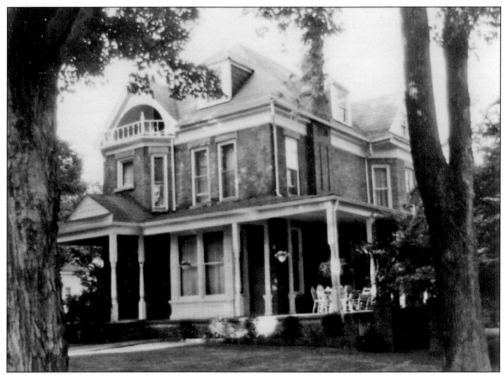

**GOODLOE RESIDENCE.** One of the Goodloe brothers who operated several businesses, John Goodloe was known as Uncle Jack. The home was purchased in the 1960s by Anthony and Ida Trigiani. The Trigiani family raised seven children in this home, one of whom is best-selling author Adriana Trigiani. Today the home is still the residence of the Trigianis on West Second Street. (Photograph courtesy of Southwest Virginia Museum.)

**JOHN AND ELIZABETH GOODLOE.** Pictured at their home are Uncle Jack and his wife, Elizabeth, who was also known as Mammy. The house to the left is the J. K. Taggart home. The house in the center, behind Mrs. Goodloe, is the Kate Ayers and L. O. Pettit home. This Victorian home burned in the 1920s. (Photograph courtesy of Southwest Virginia Museum.)

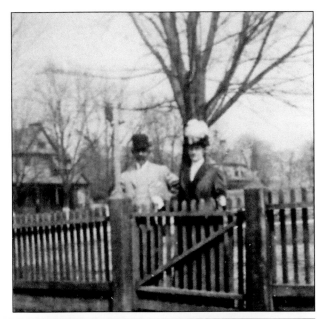

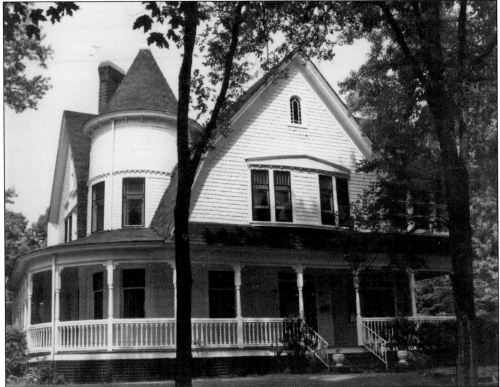

**WENTZ RESIDENCE.** Ted Wentz, general manager of the Virginia Coal and Iron Company, who disappeared on October 15, 1903, owned this home. That day, Wentz left his dogs at home, which was unusual, as they normally traveled with him. The dogs clawed a parlor windowsill, and the marks are still visible today. This home still stands on West Second Street. (Photograph courtesy of Southwest Virginia Museum.)

**TED WENTZ.** His mysterious disappearance made national headlines. Wentz left on horseback to visit C. D. Wax's home on the Guest River and never arrived. Thousands of miners and volunteers combed the mountains in search of Wentz. A decomposed body was found in May 1904 and was declared to be Wentz. A jury inquest ruled his death an accidental shooting by his own gun. (Photograph courtesy of Southwest Virginia Museum.)

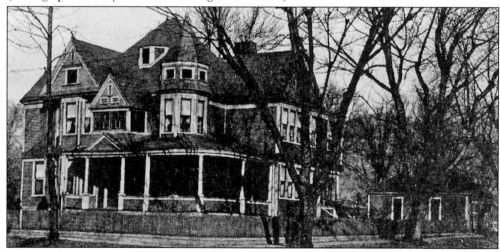

**TAGGART RESIDENCE.** J. K. Taggart became superintendent of the Virginia Coal and Iron Company in 1890. Coal production began in March 1896. Tragically, Taggart was killed on May 23, 1896, by a blast during the construction of the coke ovens. The house was occupied by D. B. Wentz from 1897 to 1904 and by E. J. Prescott from 1905 to 1945. Today this home still stands on West Second Street. (Photograph courtesy of Southwest Virginia Museum.)

**C. BASCOM SLEMP.** A native of Lee County and a longtime resident of Big Stone Gap, C. Bascom Slemp served as a congressman and private secretary to President Coolidge. Slemp was a lifelong advocate for Southwest Virginia and was instrumental in preserving its history by establishing the Southwest Virginia Museum. He also established the Slemp Foundation, which supports projects in Lee and Wise Counties. (Photograph courtesy of Southwest Virginia Museum.)

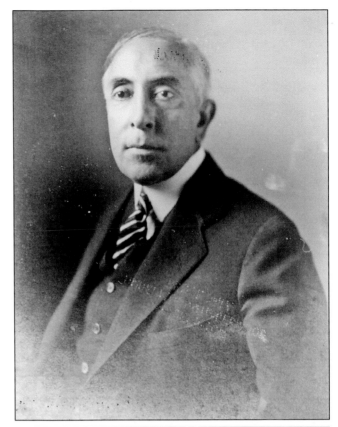

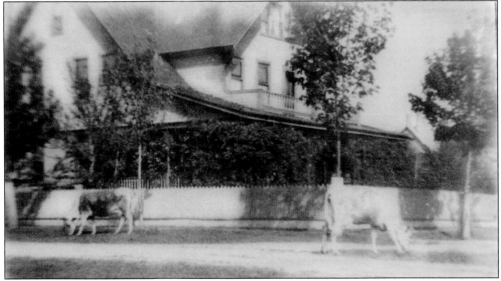

**SLEMP RESIDENCE.** This home was located on Second Street beside the Taggart home. It was originally built by W. C. Harrington in 1892 and was sold to Col. Campbell Slemp in 1895. After his death, the home was passed to his son, C. Bascom Slemp. Located behind the home was a large garage where the Janie Slemp Newman Museum was housed. Unfortunately neither building is still standing. (Photograph courtesy of Garnett Gilliam.)

**W. S. BEVERLEY RESIDENCE.** W. S. Beverly came to town in 1888. He was an original member of the police guard and served as mayor. He worked as a telegraph operator at the Monte Vista and later was a real estate agent. He was the father of the talented band director Virginia Beverly McChesney. The home was located on the corner of Shawnee Avenue and East Second Street, but it no longer exists. (Photograph courtesy of Garnett Gilliam.)

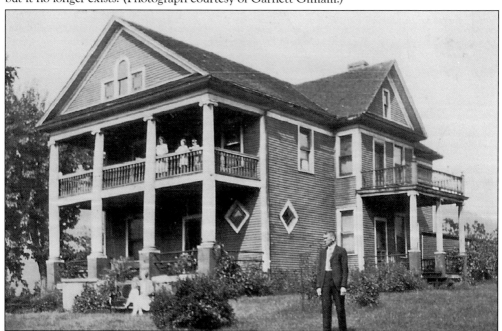

**THE POPLARS.** This home was originally named the Poplars and was owned by the Taylors. Later, in the 1940s, it was part of the Big Stone Gap School Complex. The building was used to house the principal. The home was located adjacent to the school grounds facing Wood Avenue; however, it no longer exists. (Photograph courtesy of Garnett Gilliam.)

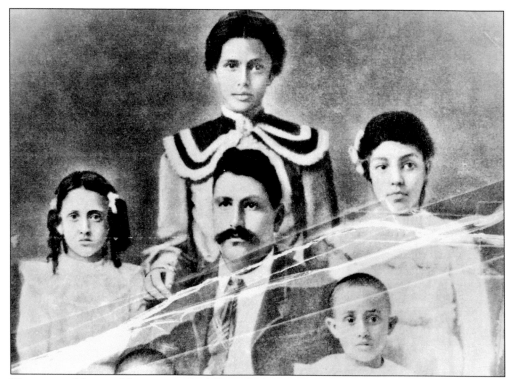

**HENRY AND MELISSA MARTIN, C. 1906.** From the beginning, African Americans were instrumental in developing Big Stone Gap. Pictured here are community leaders Henry and Melissa Martin with their children. Henry operated an early mercantile and later worked for the U.S. Post Office. His wife, Melissa, was a teacher. Both worked to start a Methodist church for African Americans. (Photograph courtesy of Southwest Virginia Museum.)

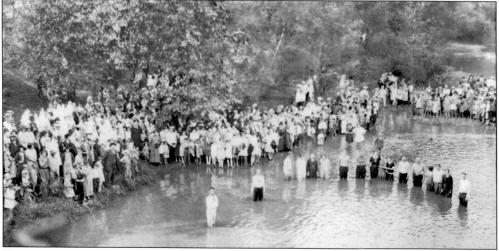

**BAPTIZING IN THE POWELL RIVER.** The Three Forks Primitive Baptist Church, established on September 3, 1798, was the first church in the area. In the 1880s, the Union Church was formed in Cadet. A Baptist church was located on East Third Street from 1890 to 1894. Services were held in the Goodloe Store on East Fifth Street until a new church could be built. (Photograph courtesy of Southwest Virginia Museum.)

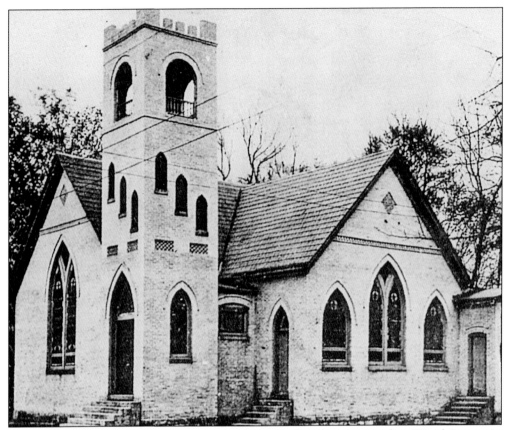

**FIRST BAPTIST CHURCH.** The new missionary Baptist church was erected on Wood Avenue in 1905. The old church, located on East Third Street, was sold to the Methodist African American congregation and became Davidson's Chapel. The First Baptist Church built an educational building in 1961, and a new sanctuary was dedicated in 1975. The white stucco church of 1905 was replaced by the present brick structure. (Photograph courtesy of C. F. and Debbie Wright.)

**EARLY VIEW OF WYANDOTTE AVENUE, 1890S.** In modern times, Wyandotte Avenue is a beautiful residential area. During the early years, the eastern end of the avenue boasted a number of businesses. Some of these included S. A. Colliers Popular Bar and Billiard Room, and Fritz's Restaurant. The house to the right was owned by D. C. Wolfe, an early merchant who owned a feed store. (Photograph courtesy of Southwest Virginia Museum.)

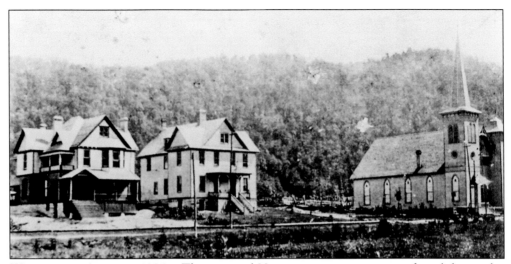

**WYANDOTTE AVENUE, 1890S.** These typical Victorian-era structures are, from left to right, the district Methodist parsonage, the church parsonage, and Trinity United Methodist Church. (Photograph courtesy of Southwest Virginia Museum.)

**TRINITY UNITED METHODIST CHURCH.** In Turkey Cove, the Methodist church was organized by 1840. In East Stone Gap, it was organized in 1881. In town, Trinity was organized in 1890 by Rev. J. O. Straley and was erected in 1891 at a cost of $4,250 by John Made, a Bristol architect. The church's early board of trustees included W. W. Nickels, J. P. Wolfe, and Campbell Slemp. (Photograph courtesy of Garnett Gilliam.)

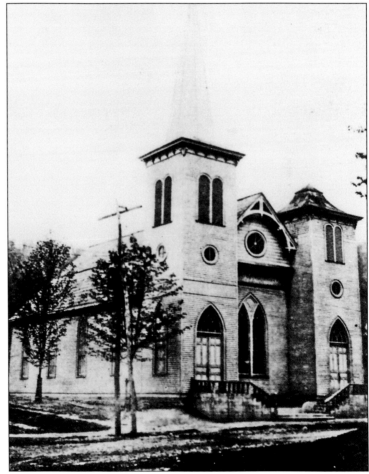

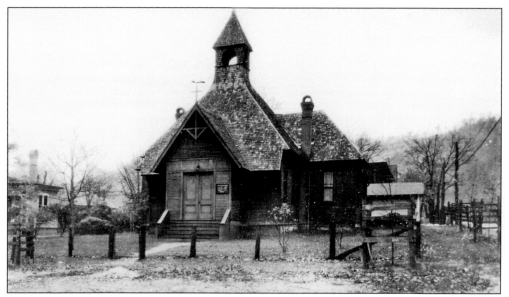

CHRIST EPISCOPAL CHURCH, C. 1900. Organized in 1890, the building was designed by Baltimore architect Buckler Chequior. The altar of the church is a relic from a mid-19th-century Episcopal church in Rustburg, Virginia. The church's red color comes from leftover barn paint from one of the original church members, J. K. Taggart. Today the red paint is a church tradition. (Photograph courtesy of Garnett Gilliam.)

EARLY VIEW OF CLINTON AVENUE. Sometime after the Episcopal church was built, the congregation added the rectory, which is seen to the left of the church. All three of the Victorian-era structures depicted in the photograph are still standing. (Photograph courtesy of Southwest Virginia Museum.)

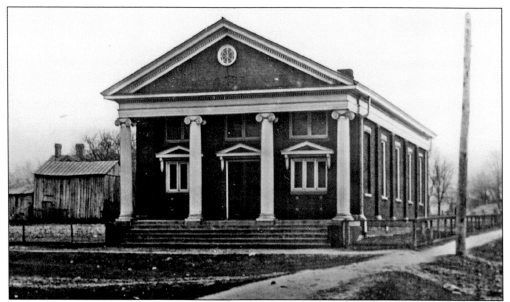

**PRESBYTERIAN CHURCH.** The Reverend Isaac Anderson was the first Presbyterian minister in the 1870s to preach at Three Forks. The Presbyterian church was formally organized by Reverend Wool, William McElwae, and Richmond Dillard, and congregated at the Duff Academy. Later it met in a store building on East Fifth Street. The present Presbyterian church was erected from 1913 to 1914 under the leadership of Rev. James Smith. (Photograph courtesy of Garnett Gilliam.)

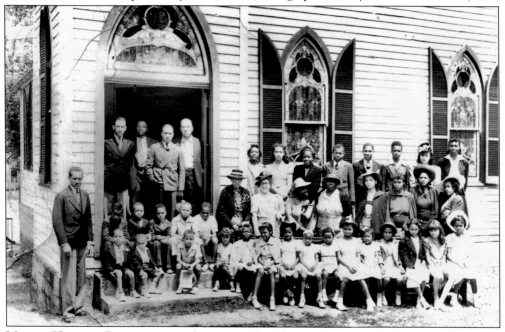

**MOUNT HERMON PRESBYTERIAN CHURCH.** The African American Presbyterian church was organized under the Freedman's Bureau of the Northern Presbyterian Church around 1893. The first pastor was Rev. G. Carter. The congregation built its first church on East Fifth Street on the north side of town. The present-day Mount Hermon Presbyterian Church was erected in 1912. (Photograph courtesy of Garnett Gilliam.)

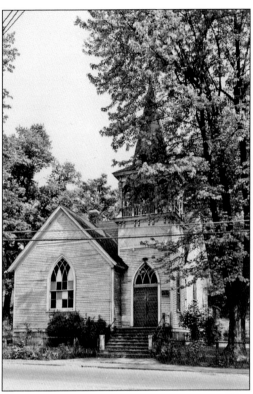

**FIRST CHRISTIAN CHURCH.** The congregation was organized in 1899 under the leadership of John West. Members met in homes and businesses until a church could be erected. Lots on Clinton Avenue were purchased for a sum of $100, and contractor W. F. Baker erected the structure. The church was dedicated in August 1901. An early church member was M. R. McCorkle. (Photograph courtesy of C. F. and Debbie Wright.)

**VICE PRESIDENT'S HOUSE.** The Stonega Coke and Coal Company was incorporated in 1902. It assumed the mine and coke oven operations built by the Virginia Coal and Iron Company from 1890 to 1896. In 1910, Stonega absorbed the Keokee Consolidated Coke Company and the Imboden Coal and Coke Company. In 1964, Stonega absorbed the Westmoreland Coal Company. Stonega was renamed to preserve the older name of Westmoreland. (Photograph courtesy of Meador Coal Museum.)

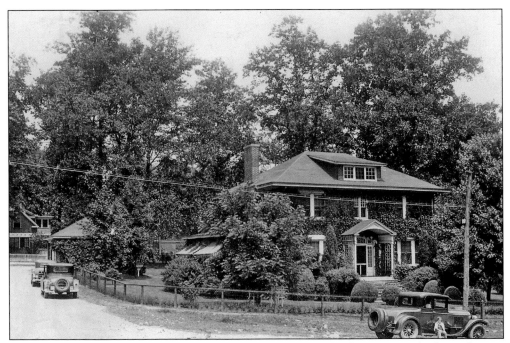

COMPANY HOUSE. Stonega Coke and Coal, later Westmoreland, maintained a home known as the company house. The home was used to accommodate and entertain visiting company officials and coal operators. It is located on West First Street South. (Photograph courtesy of Meador Coal Museum.)

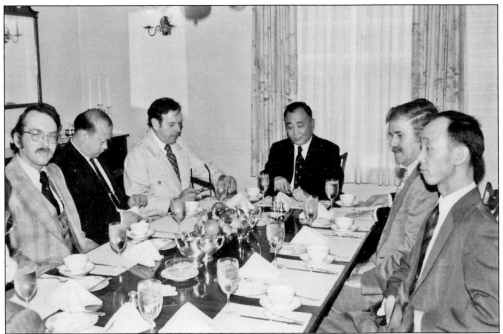

COMPANY OFFICIALS. Many elegant meals were served at the company house. Present are visiting Japanese coal buyers; Harry Meador Jr., vice president of operations (third from left); and Dan Howard (fifth from left). (Photograph courtesy of Meador Coal Museum.)

**WORKFORCE DEVELOPMENT.** Immigrants from northern European nations came to seek jobs in the developing economy because Big Stone Gap was being touted as the new "Pittsburgh of the South." Many of those immigrants arrived here by train and then traveled to an area coal camp. Place names such as Italy Bottom refer to the European immigrants who came to work at the iron furnace. (Photograph courtesy of Garnett Gilliam.)

**STONEMASON.** Charles Johnson emigrated from Sweden, where he had been educated at the University of Stockholm. He came to Southwest Virginia with the railroad to build stone train trestles for the tracks. He is credited with stonework on the Southwest Virginia Museum (Ayers residence), the Tri-State Rug (Ayers building), the Big Stone Gap School, the Poor Farm, and the Glencoe Cemetery. He married Ayers's housekeeper, Zella Missouri Payne. (Photograph courtesy of Southwest Virginia Museum.)

# *Three*
# LET'S GO DOWNTOWN

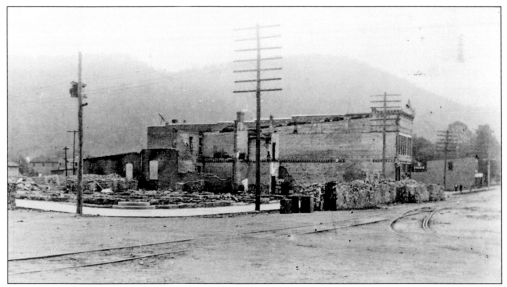

**FIRE.** The January 1908 fire destroyed buildings on Wood Avenue and East Fifth Street. The Hotel Eugene, the J. W. Kelly Building, and the Goodloe Brothers building were among 20 businesses that lost part or all of their businesses. The Ayers building was the sole survivor along Wood Avenue. The block, seen here after the 1908 fire, shows the Ayers building, which today is the Tri-State Rug and the Gift Corner. (Photograph courtesy of Garnett Gilliam.)

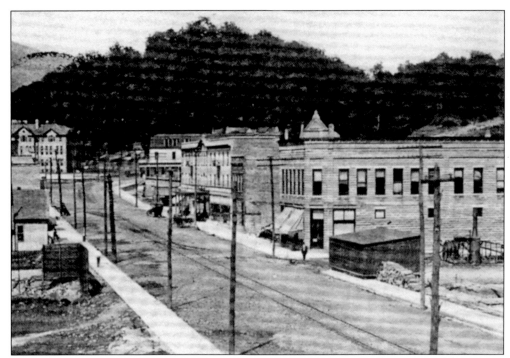

**DOWNTOWN TAKES A NEW SHAPE.** The early 1900s saw several new buildings erected downtown. Notice the Big Stone Gap School, the Tourraine, the Monte Vista Hotel, and on the right, grade work has begun for the new federal building. (Photograph courtesy of C. F. and Debbie Wright.)

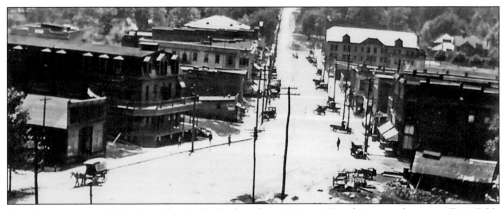

**THE TOURRAINE.** S. H. Shanklin built this hotel in 1910 on Wood Avenue between East Fifth and Jerome Streets. It could not compete and was sold in 1912 to the Home Builders Corporation, which was comprised of J. W. Kelly, C. S. Carter, and R. T. Irvine, owners of the Monte Vista Hotel. The Tourraine became an apartment building, and in 1981, a fire occurred in which two people died. (Photograph courtesy of the C. F. and Debbie Wright.)

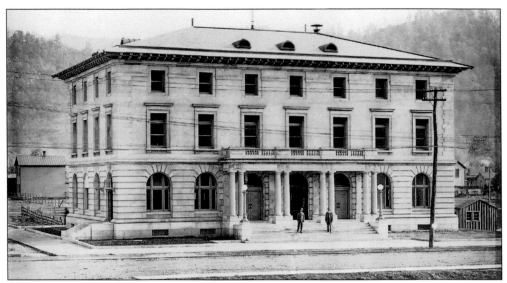

THE SLEMP FEDERAL BUILDING, C. 1915. Named for C. Bascom Slemp, the 1912 building was erected by the Plowman Construction Company of Philadelphia. At that time, the court and post office were moved from the Ayers building (Tri-State Rug) into the new courthouse. Around 1950, the courthouse was moved, but the post office remained. In 1978, the federal court was reopened at Big Stone Gap. (Photograph courtesy of C. F. and Debbie Wright.)

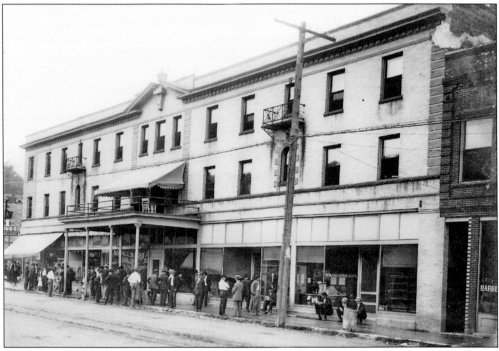

THE MONTE VISTA, C. 1915. The Monte Vista Hotel was built in 1909 after fire had destroyed the Hotel Eugene. The hotel served the finest cuisine. The opening-day menu featured three soups, six appetizers, six entrees, four vegetables, three breads, and ten desserts. Some of the items included roast ribs of export beef, roast turkey with oyster dressing, and asparagus tips on toast. (Photograph courtesy of Garnett Gilliam.)

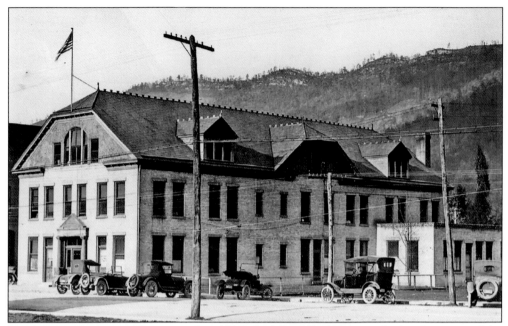

THE MINOR BUILDING. Constructed in 1908, the Minor Building was the headquarters of the Stonega Coke and Coal Company, which later became the Westmoreland Coal Company. The building was named for J. A. L Minor, an employee of the Virginia Coal and Iron Company, who came here in 1895 to develop the company's coke ovens. Minor had previously built ovens for the company at Connellsville, Pennsylvania, and Birmingham, Alabama. (Photograph courtesy of Meador Coal Museum.)

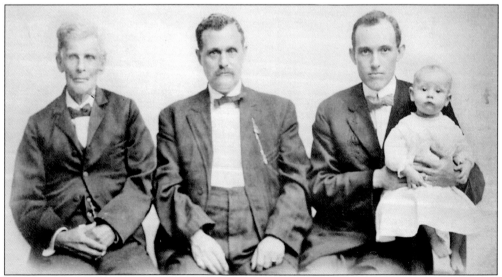

SOUTHWEST INSURANCE AGENCY. At 100 years old, the Southwest Insurance Agency is the oldest family-owned business in town. Andrew Lee Witt founded it in 1908. The original office was located in the Intermont Hotel. Three generations of the insurance agency are pictured in the photograph: (from left to right) the unnamed father of James, James Benton Floyd Witt, and Andrew Lee Witt holding Floyd Winston Witt Sr. (Photograph courtesy of the Southwest Virginia Museum.)

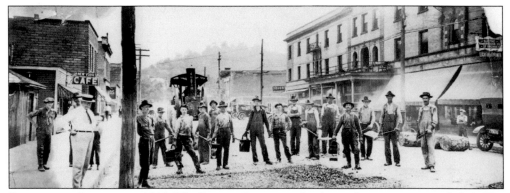

PAVING THE STREETS, C. 1919. The Dummy Line ceased to be used sometime around 1919. The tracks were removed, and asphalt crews began the hard task of paving the streets. Notice the men are spreading the tar and gravel by hand, which will be compacted with the roller. (Photograph courtesy of Southwest Virginia Museum.)

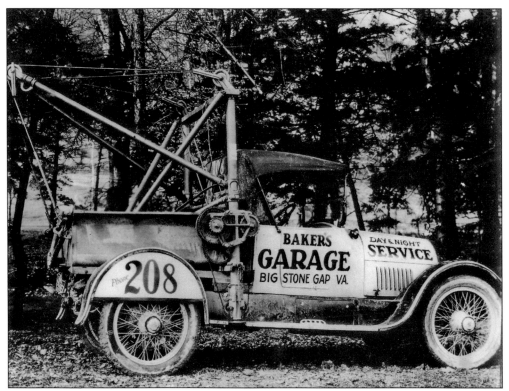

WRECKER SERVICE, C. 1919. Here is one of Baker's Garage's early wreckers. The model no. 485 was built in Chattanooga, Tennessee, in 1919. It was mounted on a 1917 Cadillac chassis. Baker's Garage was located in a wooden-frame structure known as the Summerfield building. This was on Wood Avenue across from the Minor Building. (Photograph courtesy of Garnett Gilliam.)

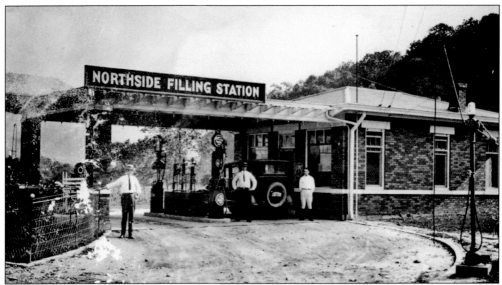

**NORTHSIDE FILLING STATION.** Located on East Fifth Street at the northern end, the filling station was managed by T. A. Morris. In the 1930s, it was a Red Triangle Conoco Station. (Photograph courtesy of Garnett Gilliam.)

**NEW YORK CAFE.** Pete Oldashi ran the cafe and is standing behind the counter; Joe Matz is having a cigar. If customers did not want to sit at the counter, they could have their choice of a booth and enjoy a good steak. The cafe offered day and night service. Just down the street was Thompson's, a favorite pool hall for the local men. (Photograph courtesy of Garnett Gilliam.)

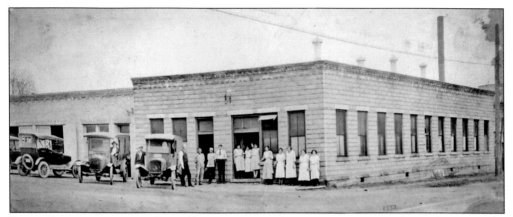

ROYAL LAUNDRY, C. 1932. Owned by J. B. Ayers and R. P. Barron, the Royal Laundry opened in 1908. A Mr. Moore, an experienced laundryman from New York, was the manager. Route wagons ran from Appalachia, Stonega, Blackwood, and other area towns. It was later sold to R. B. and W. T. Alsover. Robert Barron is the third man from the left in the picture. (Photograph courtesy of Southwest Virginia Museum.)

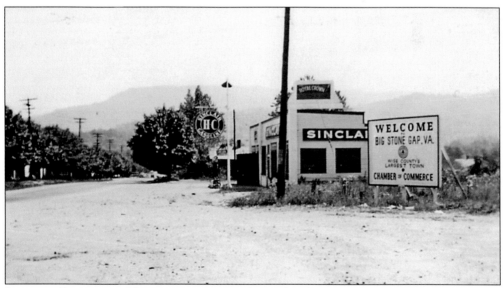

SINCLAIR GAS, 1930s. This service station was located at the entrance to town from Appalachia. Notice that the welcome sign advertises the town as the largest in the county. Today Big Stone Gap is the largest town in the four counties located in the far southwest corner of the state. (Photograph courtesy of Garnett Gilliam.)

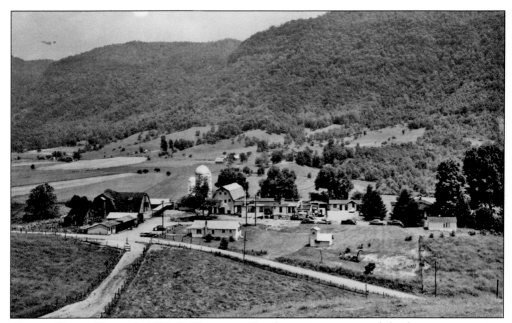

**CLINCH HAVEN FARM.** In 1922, D. Terpstra, a Dutch immigrant, started the farm on a part-time basis. The dairy provided milk for coal camp children. In 1928, Terpstra began farming full-time and ran the farm until 1972. At that time, the Galloway and Peace families purchased the farm. The Peace family still farms part of the original land, although it no longer produces dairy products. (Photograph courtesy of Garnett Gilliam.)

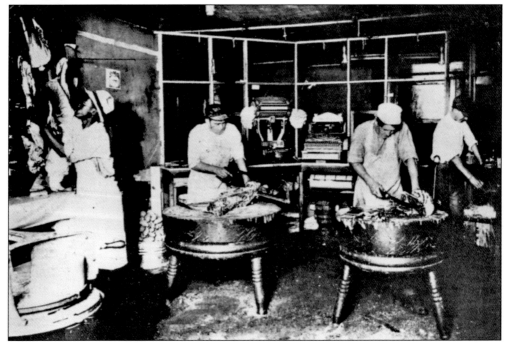

**BUTCHERS.** The town had a number of early butcher shops. Some of these shops included the City Meat Market, Lane's Meat Market, Carnes and Company, J. M. Collier, Hisel's Meat Market, W. E. Yeary's Meat Market, and Cash Meat Market. (Photograph courtesy of Garnett Gilliam.)

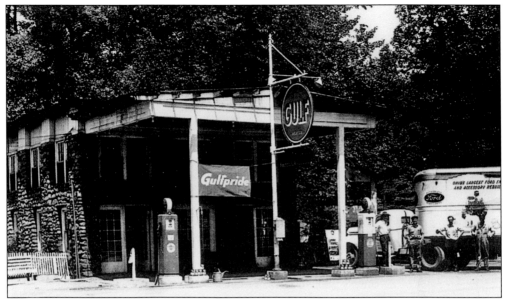

ROCK HOUSE SERVICE STATION. Located at the corner of East First Street and Wood Avenue, this service station was operated by Bill Rush. It originally had both a station and a sandwich shop. Later Rush added some apartments. The service station was a popular place to meet and catch up on the local news. Luke Mahan later managed the station. (Photograph courtesy of Garnett Gilliam.)

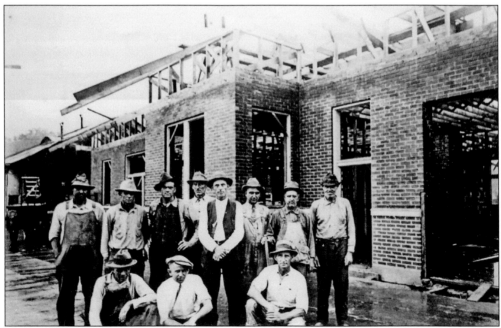

BUILDING THE HOSIERY FACTORY, C. 1920. Located between East Ninth and East Eleventh Streets and First Avenue East to Second Avenue East, the hosiery cost approximately $300,000 to build and equip. The Taubel-Scott-Kitzmiller Company owned the factory. At full capacity, the mill could manufacture 12,000 pairs of hose daily. (Photograph courtesy of Southwest Virginia Museum.)

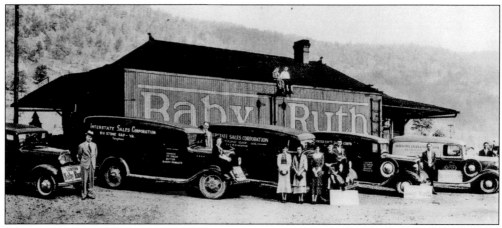

**INTERSTATE SALES CORPORATION.** This candy promotion took place at the Southern Railway train depot. Early Big Stone Gap had a number of retail candy stores. In the 1930s, Corbett Chambers ran a wholesale candy company in the town. The company sold candy in the coalfields of Virginia and Kentucky. A later wholesale company was the Coland Candy Company, which was operated by Henry Stout. (Photograph courtesy of C. F. and Debbie Wright.)

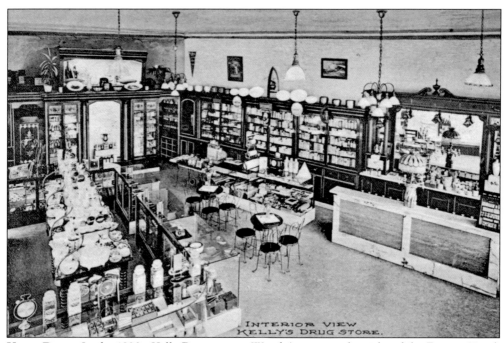

**KELLY DRUG.** In the 1890s, Kelly Drug was on Wood Avenue to the right of the Eugene Hotel. Dr. J. W. Kelly advertised his drugstore as a dealer in "Pure Drugs and Patent Medicines." After the 1908 fire, Kelly relocated to the corner of Wood Avenue and East Fifth Street. The tiled word "drugs" in Miners' Park is a remnant of the entrance to the drugstore. (Postcard courtesy of C. F. and Debbie Wright.)

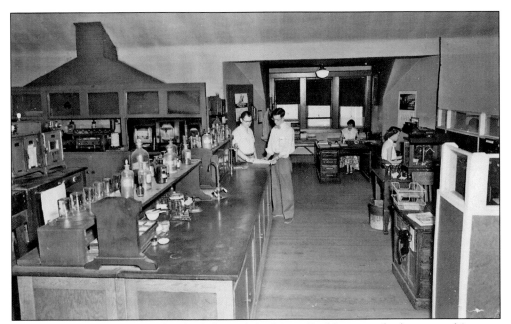

**STONEGA CHEMICAL LAB.** The third floor of the Minor Building was the location of Stonega Coke and Coal's chemical and engineering departments. The first and second floors of the building were used as office space. The company spent large amounts of money in development of its properties to supply the coal demand caused by World War I and reconstruction. (Photograph courtesy of Meador Coal Museum.)

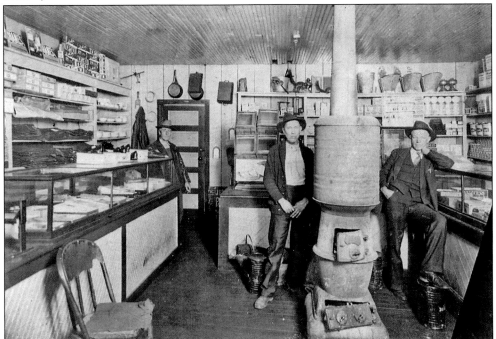

**W. W. HUGHES STORE.** Picture from left to right are W. W. Hughes, Mathew Hammonds, and J. D. Willis. The W. W. Hughes Store was located on East Fifth Street at the current site of the Gas and Go. (Photograph courtesy of Garnett Gilliam.)

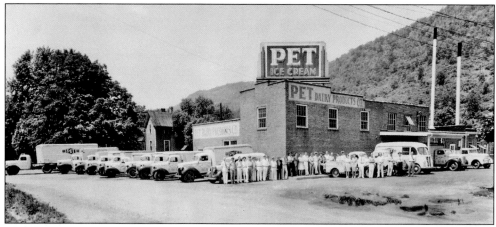

**PET DAIRY, C. 1944.** The original dairy business was Mountain View Dairy, which was located in Powell Valley. It was started in 1926 and moved to Big Stone Gap in 1929. The business was then leased to Pet Dairy in 1932. Pet Dairy employed many people over the years. Jimmy Smith was a familiar face as the milkman for Big Stone Gap. (Photograph courtesy of Garnett Gilliam.)

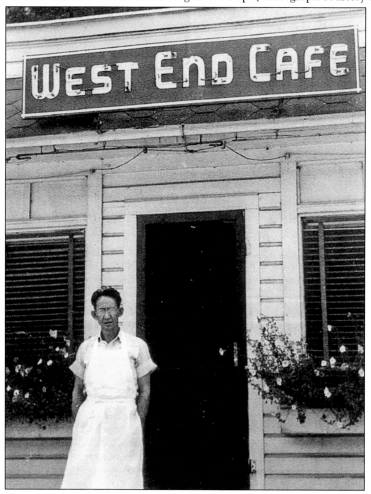

**THE GREASY SPOON, 1930s.** The popular drinking establishment's business name was the West End Cafe. However, it was affectionately known as the Greasy Spoon. Frank Davis operated it. The cafe was located on the left just west of the present-day Jessie Lea Campground. (Photograph courtesy of Garnett Gilliam.)

**MOUNTAIN HOME TOURIST CAMP.** The tourist hotel was built in 1934 and originally consisted of six cottages. The construction cost on the initial teepee-shaped house was $2,600. The camp grew to 15 cabins; visitors who did not rent a cabin could pitch a tent. The tourist hotel was built by Jim Burchette and D. F. Barker, and was operated by Burchette. It was located near Auto World. (Photograph courtesy of Garnett Gilliam.)

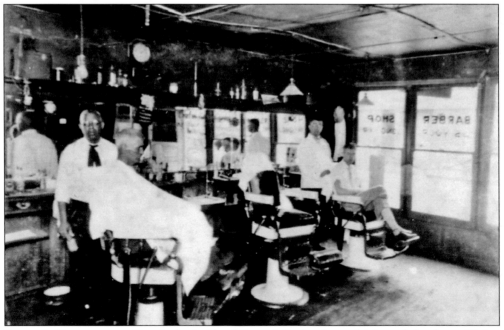

**SPEARS'S BARBERSHOP.** Here is the inside of Spears's Barbershop, which used the slogan "Bring Us Your Long Hair." Pictured cutting hair are Lon Spears (left) and Tom Warren. The barbershop was located on East Fifth Street in the present-day Trail Antiques building. (Photograph courtesy of Southwest Virginia Museum.)

**ROGERS' GULF.** Located on the corner of East Fifth Street and Gilley Avenue, the Rogers' Gulf Service Station was opened on a snowy March 17, 1960. William Rogers and his family ran the station for 31 years at this location. The business was then moved to the Gulf Tower on Wood Avenue, where it operated for another seven years. (Photograph courtesy of Garnett Gilliam.)

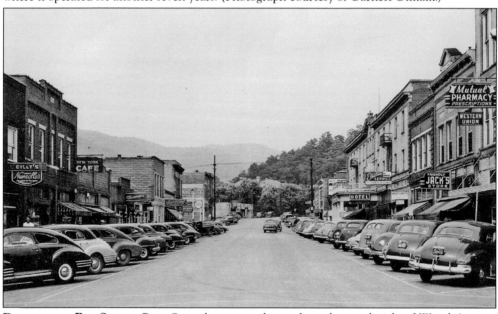

**DOWNTOWN BIG STONE GAP.** Some businesses located on the north side of Wood Avenue included Gilley's, the New York Cafe, Thompson's, Mrs. William's Cafe, Sportland, Pennington's Hardware, and the Big Stone Gap Feed Store. Some businesses located on the south side of Wood Avenue included the Mutual Pharmacy, Western Union, Friendly Jack's Store, Well's Land Company, Old Dominion Power, the Monte Vista Hotel, Kelly Drug, and the Big Stone Gap Theater. (Photograph courtesy of Garnett Gilliam.)

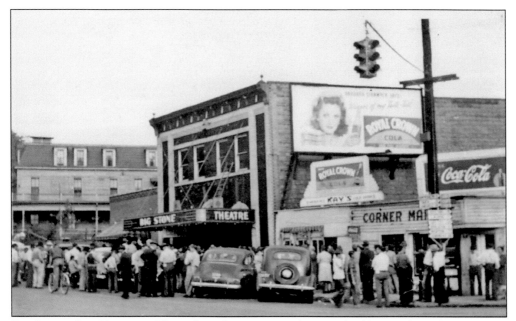

**BIG STONE GAP THEATER.** The earliest theater was in the Ayers building in the early 1900s. The next theater was the Amuzu, which was pronounced *amuse you*. This theater opened in 1912 and was managed by J. R. Taylor. The Amuzu later became the site of the Big Stone Gap Theater. Tuesday was bargain day and cost 11¢ for all. (Photograph courtesy of C. F. and Debbie Wright.)

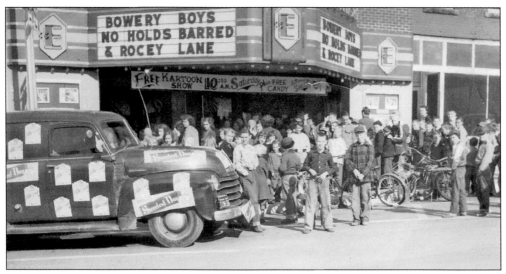

**EARLE THEATER.** After the Amuzu and Big Stone Gap Theater, the Earle was opened on Wood Avenue in 1949. Earle Mullins of Norton owned this theater as well as the Keokee Theater. Later the Trail Theater opened next to the Minor Building. During the 1950s, the Powell Valley Drive-In opened. Today there are no movie theaters in Big Stone Gap. (Photograph courtesy of Garnett Gilliam.)

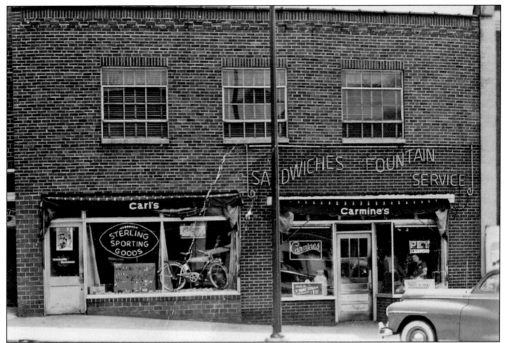

CARMINE'S. In 1944, Carmine Murphy opened Carmine's Canteen while her husband, Carl, served in the South Pacific. The canteen offered sandwiches, ice cream, soft drinks, and candies. When Carl returned from service, a bigger building was constructed on Wood Avenue, and the popular teenage hangout grew. In 1956, Carmine's opened an additional dining room. Carmine's was known for its great hot dogs and pies. (Photograph courtesy of Garnett Gilliam.)

ORIGINAL COUNTRY BOY. Pictured is opening day of the original Country Boy, which was located on Shawnee Avenue across from the present-day fire hall. The man standing in the left of the picture is Jack Gardner. In 1956, the popular restaurant moved to its location on Gilley Avenue. (Photograph courtesy of Garnett Gilliam.)

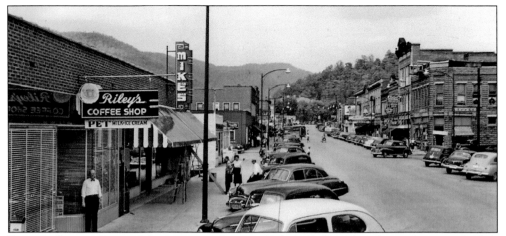

**RILEY'S COFFEE SHOP.** After a series of moves, Riley's Coffee Shop located next to Mike's Department Store on Wood Avenue in 1949. The popular coffee shop was open 24 hours a day and used the slogan "We Doze But Never Close." It was operated by Mr. and Mrs. J. S. Riley and had a menu of regular meals, short orders, steaks, and seafood. (Photograph courtesy of C. F. and Debbie Wright.)

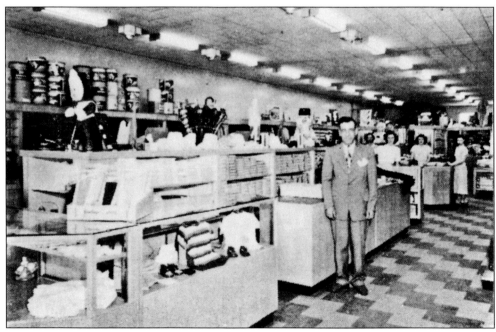

**MIKE'S DEPARTMENT STORE.** This photograph depicts the inside of Mike's Department Store, which was located on Wood Avenue. The card was sent by George Salaita to celebrate the 30th anniversary of the store that his father began in 1948. The store special for the anniversary was 20 percent off all men's clothing and shoes. (Photograph courtesy of Garnett Gilliam.)

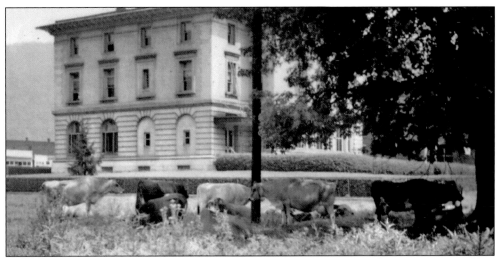

COWS. In the early town, cows were allowed to roam free. In 1909, the Women's Civic League caused quite a debate when they appealed to the town council to require owners to confine the cows to lots and remove their bells at night. The ladies were accused in an editorial of "agitating" the cow question. (Photograph courtesy of Southwest Virginia Museum.)

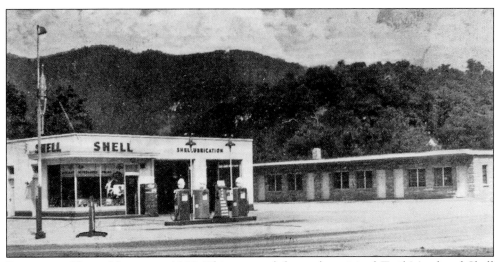

SHELL AND TRAIL MOTEL, C. 1948. This postcard shows the original Trail Motel and Shell Service Station. The advertisement was "Your car is our businesses, 24 hour service-Have your car serviced while you spend a restful night in our modern motel." (Postcard courtesy of C. F. and Debbie Wright.)

**BANKS.** Rufus Ayers, Patrick Hagan, and others organized the Interstate Finance and Trust Company in 1902. The bank failed in 1907 and, in 1908, reorganized as the New Bank. In 1920, it became the First National Bank. The bank was under the leadership of J. B. "Duck" Wampler through the 1950s. After a merger in 1965, the bank became the First National Exchange Bank. (Photograph courtesy of Garnett Gilliam.)

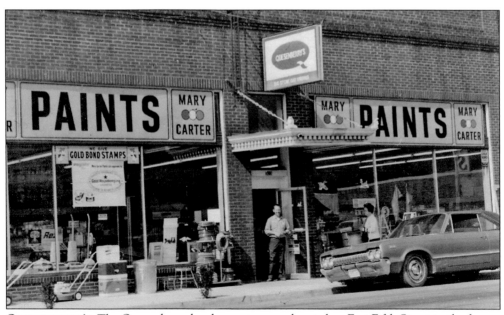

**QUESENBERRY'S.** The Quesenberry hardware store was located on East Fifth Street in the former Kelly Chevrolet building. Quesenberry Construction was started in the 1950s by M. S. Quesenberry Jr., who invented the jeep lifter while in the army. The lifter was a disc that, when attached to a jeep's wheels, enabled the disabled jeep to pull itself out of a ravine on its own power. (Photograph courtesy of Garnett Gilliam.)

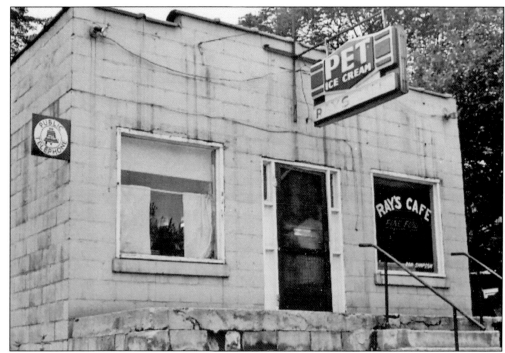

RAY'S CAFE. Located on Railroad Avenue, Ray's Cafe was known for having the best fried fish in town. The fish features were flounder and black bass. Ray and Lilly Mae Barnes ran the cafe, which was usually packed on Friday and Saturday. After the Barnes family sold the cafe, Rand Simpson, Sam Harding, and Paul Coughlin owned it in succession. (Photograph courtesy of Garnett Gilliam.)

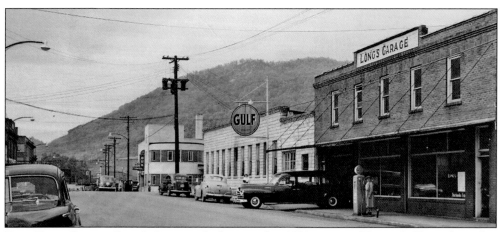

EAST FIFTH STREET. Long's Garage, which opened in 1911, is part of Dotson's Chevrolet today. The next white building is the Royal Laundry. Visible beyond the laundry is the bus station. Robert Edens operated the bus station for the Tri-State Coach Company, and his Liberty Cafe was located within the terminal. He later also opened the Sandwich Shoppe next door. (Photograph courtesy of C. F. and Debbie Wright.)

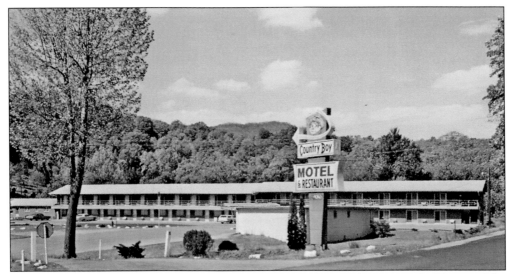

COUNTRY BOY MOTEL AND RESTAURANT. It was more than a place to eat for 28 years. The restaurant served as a gathering place for teens, a date hangout, and was the place to cruise. The Gardner family moved the restaurant to the Gilley Avenue location in 1956, and motel units were built shortly thereafter. The motel is still in operation as the Country Inn. (Postcard courtesy of C. F. and Debbie Wright.)

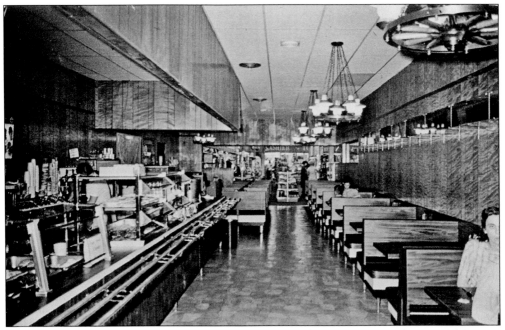

THE MUTUAL. Originally located next to the Ayers building, the present-day Mutual Drug is located next to the courthouse. A community icon, the Mutual, as it is commonly referred to, was made famous in Adriana Trigiani's book *Big Stone Gap*. The lady in the right of this postcard is Pat Bean. (Photograph courtesy of C. F. and Debbie Wright.)

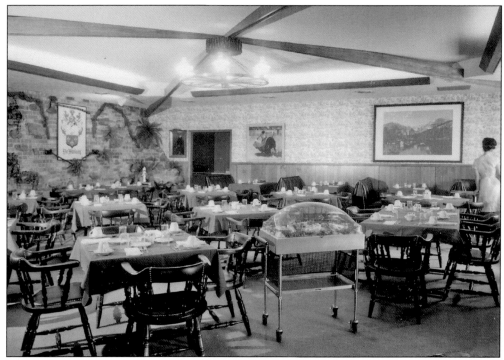

**COACH HOUSE RESTAURANT.** One of the town's most popular eating establishments, the Coach House was located at the Gilley Avenue and East Fifth Street intersection. The restaurant was built by Frank DeMossey and later was sold and became Fraley's Coach House. (Photograph courtesy of Garnett Gilliam.)

**COOKING CHICKEN.** A popular story about the Coach House Restaurant involved the actress Elizabeth Taylor and chicken. One of her husbands was John Warner. Taylor accompanied him to Big Stone Gap for his senate campaign. She choked on a chicken bone and was rushed to the hospital. The incident is immortalized in the novel *Big Stone Gap*. (Photograph courtesy of Garnett Gilliam.)

*Four*

# THE THREE RS

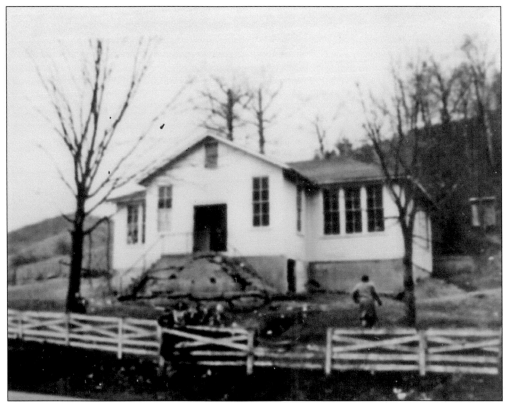

**BUFFALO SCHOOL.** Ministers of the Three Forks Primitive Baptist Church, John Tate and Isaac Willis, formed a satellite church near the present-day Lonesome Pine Country Club. This church founded the Jones School, taught by Isaiah Jones, in 1846. This is reported to be the first school in Wise County. Later it was called the Buffalo Academy and became a feeder school for East Stone Gap. (Photograph courtesy of Garnett Gilliam.)

**BLUE SPRING CHURCH AND SCHOOL.** The congregation of the satellite church of Three Forks Baptist Church that was located in Powell Valley dispersed after the Civil War. A fragment survived to form the Blue Spring Church and School. The school was located at the intersection of Butcher's Fork and Route 610. It was torn down in the 1980s. (Photograph courtesy of Garnett Gilliam.)

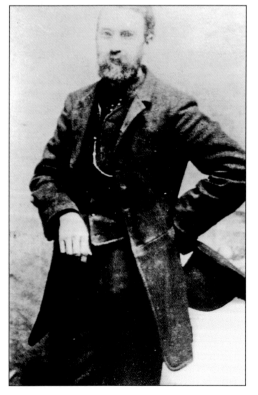

**JEROME DUFF.** In the 1880s, to educate his children, Jerome Duff brought teacher Virginia Frizzell Parrish to Big Stone Gap. Her first sessions were taught in the attic of the Central Hotel. Duff then built a little schoolhouse, the Duff Academy, behind the hotel. In addition to the Duff children, J. B. Mills's children along with Bettie Churchill and French Kunkel attended classes at the Duff Academy. (Photograph courtesy of Garnett Gilliam.)

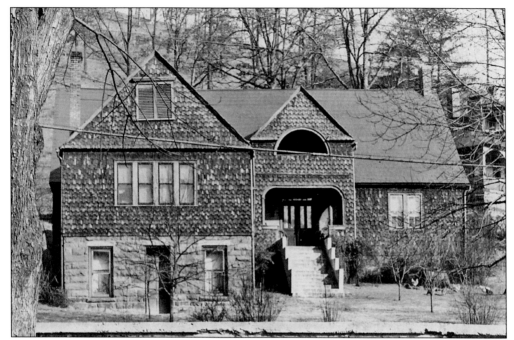

**STONEGA ACADEMY.** The first formal school was the Stonega Academy, established around 1891. The first professor, William Beckford, set up a private school with a cost of $75 per year for five subjects per semester. The school was originally unnamed but later acquired the name Stonega Academy. C. Bascom Slemp served as principal from 1893 to 1895. The structure was torn down in 2002. (Photograph courtesy of Garnett Gilliam.)

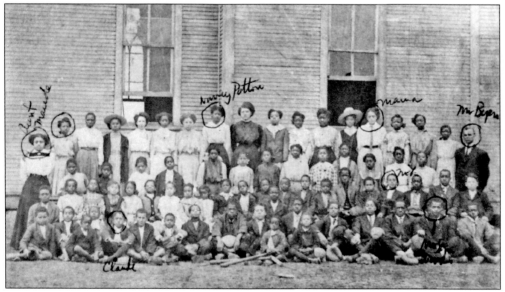

**EARLY AFRICAN AMERICAN SCHOOL.** By 1891, the Reverend Noah Wilson started a school for African Americans in a church. Around 1912, the Presbyterian church was erected on Gilley Avenue, and school was soon started there. A Mr. Buyers, a graduate of the Virginia Normal and Industrial Institute in Petersburg, set up the school. Maude Martin Spears was the first teacher, along with Mr. Buyers. (Photograph courtesy of Southwest Virginia Museum.)

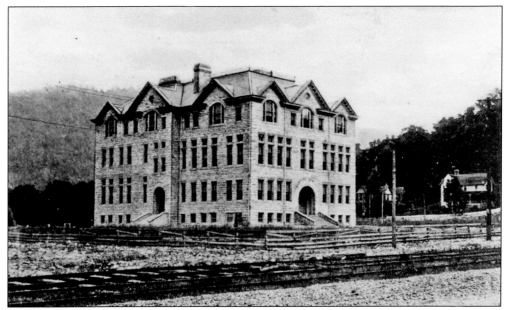

**BIG STONE GAP SCHOOL.** Population growth created the need for public schools. Rufus Ayers, J. W. Kelly, and J. F. Bullitt were instrumental in establishing the public school. Construction was begun in 1900 and was completed around 1903. John Milbourne designed the structure, and the stonework was completed by Charlie Johnson. It had 15 rooms, accommodated 450 pupils, and cost $17,000. R. H. Sheppe was the first principal. (Photograph courtesy of C. F. and Debbie Wright.)

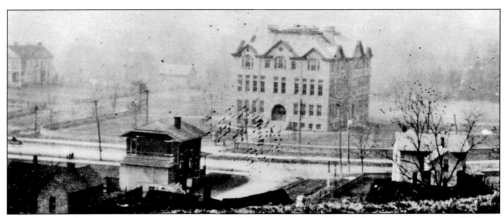

**VIEW OF SCHOOL.** Here is an early view of the Big Stone Gap School as it appeared along Wood Avenue. The grounds of the school were surrounded by a stone wall that matched the stonework of the structure. In the left of the photograph is the Taylor home. In the foreground is one of the earliest residential structures. This brick home still stands today. (Photograph courtesy of Garnett Gilliam.)

**NORMAL SCHOOL TEACHERS.** During the summer, the school became the site of a normal school. Its purpose was to prepare people of Southwest Virginia to take examinations to become schoolteachers and principals. In 1906, it was one of 10 normal schools in the state of Virginia. (Photograph courtesy of Garnett Gilliam.)

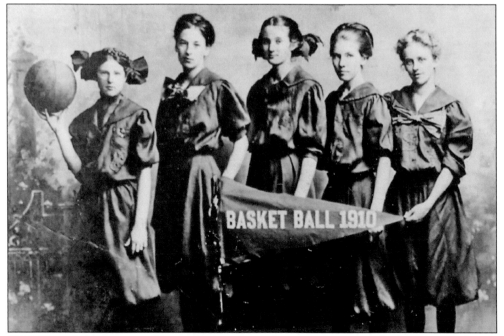

**1910 GIRLS' BASKETBALL TEAM.** During the early years, there were both male and female basketball teams but no football. Pictured from left to right are Jo Kelly, G. Parsons, K. Horton, G. Wolfe, and Mary Carnes. (Photograph courtesy of Garnett Gilliam.)

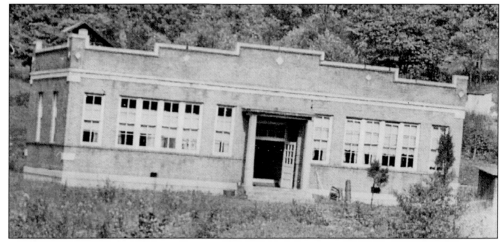

**HORTON ELEMENTARY SCHOOL.** This school was located in the strawberry patch area about two miles west of town. The school, at various times, went by the Horton School, the Strawberry Patch School, and the Neely School. There was also a school at Oreton, which was a mission schoolhouse of the Presbyterian church. (Photograph courtesy of C. F. and Debbie Wright.)

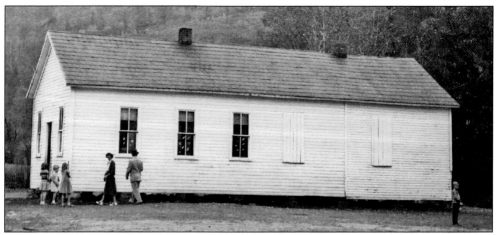

**DORTON'S CHAPEL SCHOOL.** J. M. Dorton donated the land for a school in Cracker's Neck that was opened in 1890. The school was later moved to another site, where it stood until 1960. Grades first through third were taught at the school, and then students attended East Stone Gap. (Photograph courtesy of Garnett Gilliam.)

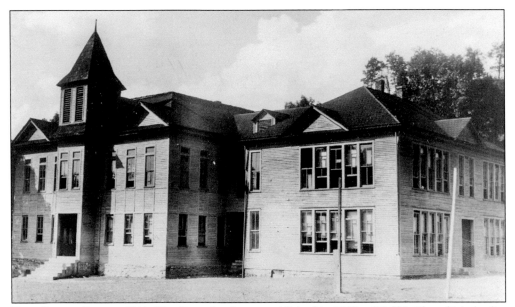

EAST STONE GAP, C. 1911. The first school was established in 1882 at Wolfe's Chapel Methodist Church. As enrollment grew, a new four-room building was erected in 1890. In 1905, an even larger school was built on a nearby site. This became East Stone Gap Graded School, which taught students in fifth, sixth, and seventh grades. (Photograph courtesy of Garnett Gilliam.)

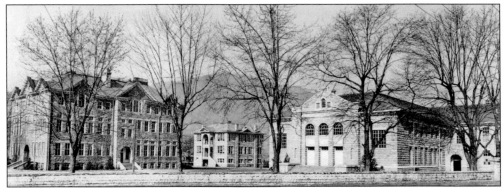

BIG STONE GAP SCHOOL COMPLEX, C. 1923. The Big Stone Gap School was expanded (left) and a high school building (center) opened in the school year of 1922–1923. Additional classes such as home economics, agriculture, and civics were added. A third building, an elementary school building (right), was added in 1925. This building featured a large auditorium and a gymnasium. These buildings operated until 1959. (Photograph courtesy of Garnett Gilliam.)

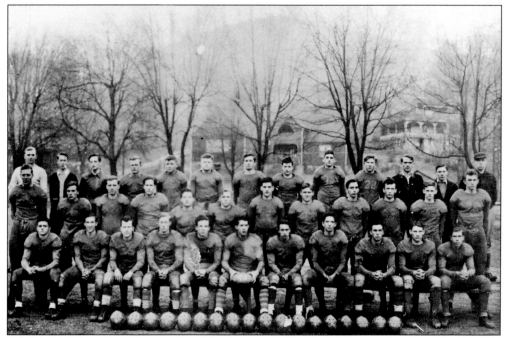

**BUCCANEER FOOTBALL TEAM, 1940.** The first county football game was played in October 1923 between Big Stone and East Stone Gaps. It was a hard-fought contest on both sides, with the Buccaneers scoring in the first quarter. The game ended with a score of Buccaneers six and Tigers zero. Big Stone Gap went on to win everything that first football year, defeating Norton, Coeburn, and Middlesboro High Schools. (Photograph courtesy of Garnett Gilliam.)

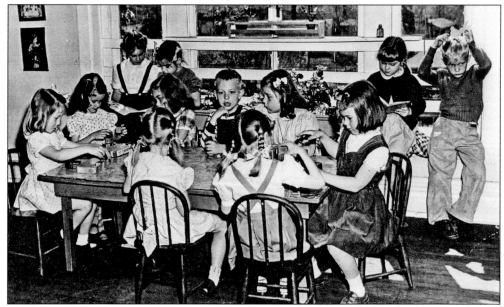

**KINDERGARTEN CLASS OF 1947.** These youngsters were in Mrs. Gordon's class. Pictured are Jo Susan Holyfield, Nita Holding, Alice Darnell, Johnny McCrary, Suzanne Reed, Sheila Bishop, Winfield Rose, Betsy Banks, Ann Broadwater, Janet Renshaw, Ann Little, and Reida Rankin. (Photograph courtesy of Garnett Gilliam.)

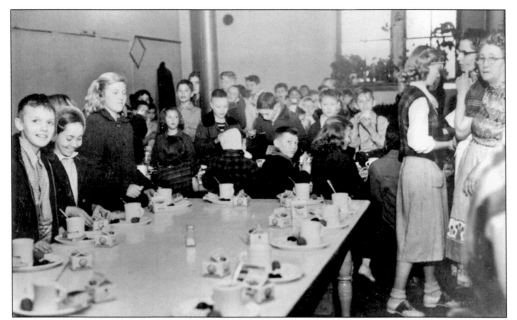

CAFETERIA, C. 1950. Children who lived close by often walked home for lunch. Others ate in the school cafeteria. Frozen items for cooking were stored at Pet Diary because the school did not have freezers. The high school students went through the line first and took their food back to eat in their classrooms. The elementary students stood at tables during lunch. (Photograph courtesy of Garnett Gilliam.)

PRIMARY SCHOOL FOR AFRICAN AMERICANS, C. 1941. Throughout the early 20th century, most young African American students were educated in area churches. In the 1930s, children were bused to a primary school on Hamblen Street. Grades one through nine were taught at the school. Talmadge Warren and Mack Patton are in first grade in this picture. (Photograph courtesy of Garnett Gilliam.)

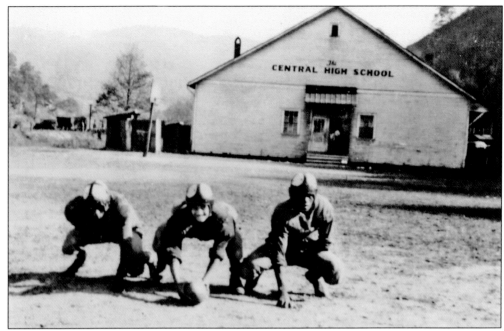

**CENTRAL HIGH SCHOOL, 1940s.** Originally known as the Appalachia Training School, the African American school opened in 1938. The name was then changed to Central High School, as suggested by principal C. H. Shorter. Children were first brought by car and then by bus from Big Stone Gap to attend the school. (Photograph courtesy of Garnett Gilliam.)

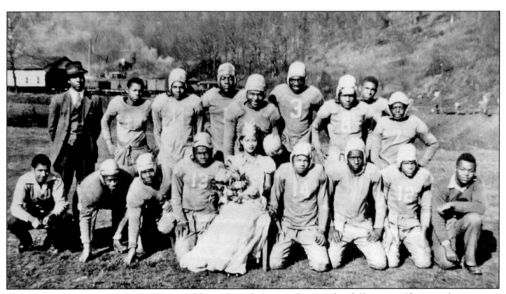

**CENTRAL FOOTBALL, 1942.** Pictured here from left to right are the following: (first row) manager Jessie Sommers, Willie Neal, Sammy Copeland, James Alexander, homecoming queen Gwendolyn Prichitt, Henry Horton, Twilly Bellamy, Henry Delaney, and Eugene Bryant; (second row) coach Linwood Graves, John Simpson, William Strauss, James Bellamy, captain Harold Simpson, Arthur Marcy, Eugene Traylor, George Jackson, and Wesley Neeley. (Photograph courtesy of Garnett Gilliam.)

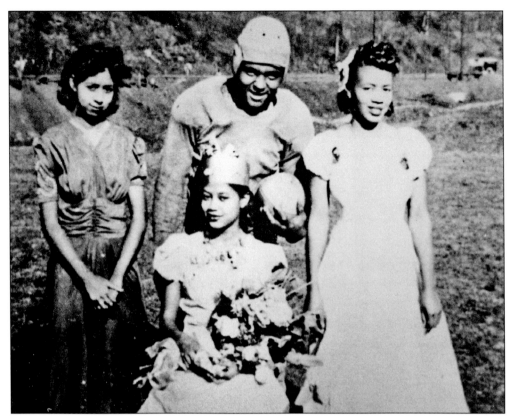

CENTRAL HOMECOMING QUEEN. The court included (standing) Elizabeth Hoskins, football captain Harold Simpson, Hattie Moss, and (seated) homecoming queen Gwendolyn Prichitt. (Photograph courtesy of Garnett Gilliam.)

BLAND HIGH SCHOOL. In 1954, the new James A. Bland High School for African Americans opened on East Fifth Street in Big Stone Gap. The structure cost $300,000 to build and still stands today as the town hall. After integration in the 1960s, the Bland School became Carnes Middle School. It was named for Rex Carnes, a respected teacher and coach at Bland High School. (Photograph courtesy of Garnett Gilliam.)

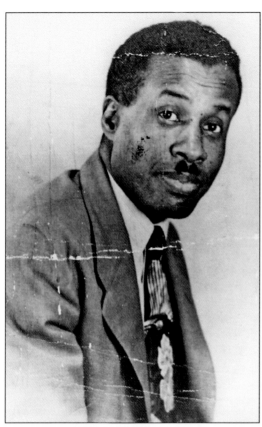

**C. H. Shorter.** Before 12 grades were available at Central or Bland High Schools, area youth were sent on to Swift Memorial Jr. College at Rogersville, Tennessee. Afterward, many attended one of the African American colleges such as Knoxville College, Virginia State College, and LeMoyne College. C. H. Shorter, a beloved principal at Central and Bland, received his bachelor's degree in mathematics and chemistry from Knoxville College. (Photograph courtesy of Garnett Gilliam.)

**Bland Senior Class, 1958.** Pictured here from left to right are the following students: (first row) Tyrone Taylor, Alonzo Gover, Earline Swift, Carol Skaggs, Mary Flanary, Barbara Reasor, Jacqueline Rier, Ted Barnes, and Cleo Mitchell; (second row) Robert Jones, Bobby Zander, Perl Long, Carson Carnette, Curtis Burney, Ernest Hollinger, and Ernest Horton. (Photograph courtesy of Garnett Gilliam.)

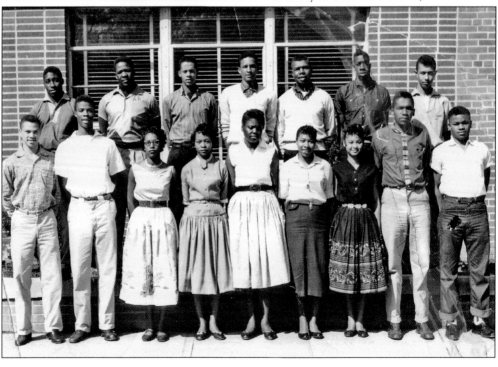

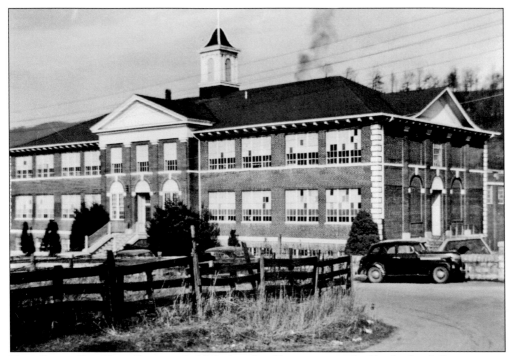

**EAST STONE GAP HIGH SCHOOL.** In 1912, the school became a standard high school. Construction was completed in 1925 on a larger, brick building. A Mr. Jones became the principal during that year. In 1931, a modern gymnasium was added. (Photograph courtesy of Garnett Gilliam.)

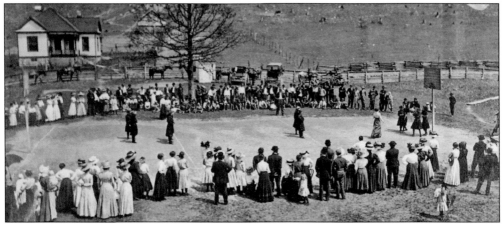

**EAST STONE GAP VERSUS NORTON, 1909.** The first Inter–High School Athletic Contest that included a girls' basketball team was held in 1909. The lineup for East Stone Gap included Mabel Carnes, Mollie Hurd, Pearl Gilley, Kate Berry, and Ethel Lawson. East Stone Gap won by a score of 27-15. (Photograph courtesy of Garnett Gilliam.)

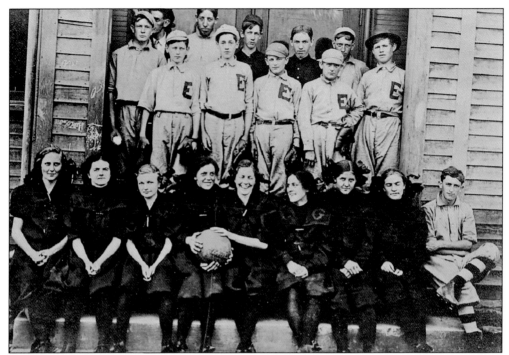

BASEBALL AND BASKETBALL TEAMS, C. 1900. Early East Stone Gap teams pose together. A school cheer was, "We don't give a hobble gobble, bife, boom, bah! Smash 'em! Bust 'em! That's our custom! East Stone Gap School! Rah, rah, rah!" (Photograph courtesy of Garnett Gilliam.)

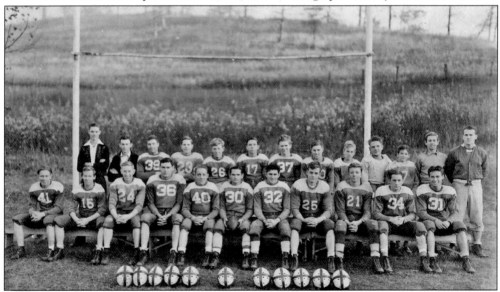

EAST STONE GAP FOOTBALL TEAM, 1941. Pictured from left to right are the following: (first row) Pat Morris, Cecil Jones, Jack Gardner, Paul Blevins, I. F. Burke, Billy Barker, Ewing Collier, Ralph Bryington, George Mullins, Gilbert Wade, and Austin Jones; (second row) Radford Jessee, Hubert Hood, Fred Osborne, Orville Jones, Red Maness, Fred Gibson, Ralph Cummins, Larry Slagle, Edward Baker, Kenneth Durham, W. T. Galliher, Bruce Carter, and coach Larry Britton. (Photograph courtesy of Garnett Gilliam.)

CENTRAL BEAUTY SCHOOL. Other schools in the area included the Highland Technical Institute, which was founded in 1905 with John Hale Larry as president. The institute offered four departments: academic, business, music, and household economics. Also during the 1960s, Alma Esteppe operated the Central Beauty School on East Fourth Street. Pictured is the 1963 graduating class. (Photograph courtesy of Brenda Smith.)

POWELL VALLEY HIGH SCHOOL. In 1956, forty acres of the Taylor Farm were purchased for a new Big Stone Gap–East Stone Gap consolidated high school. Powell Valley High School opened in 1959, with the first graduating class in 1960. The principal was Harley Stalled, and the Vikings' football coach was Burchell Stallard. Other faculty included long-time educators like Faith Cox, Billy Jean Scott, and Jack Gibbs. (Photograph courtesy of Garnett Gilliam.)

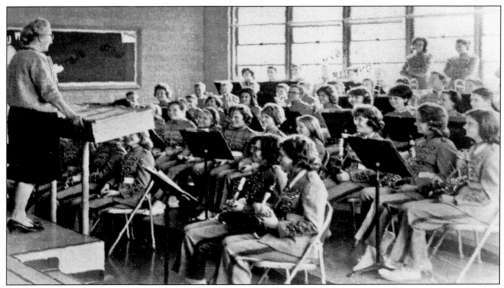

VIRGINIA MCCHESNEY. Born in 1896, "Mrs. Mac" attended Julliard and graduated from the Cincinnati Conservatory. She founded the high school band in 1937 and taught for 14 years without a salary. During World War II, Mrs. Mac was the band director at Norton, Wise, Appalachia, East Stone and Big Stone Gap High Schools. Her reputation was legendary. The International Association of Women Band Directors honored her in 1972. (Photograph courtesy of Garnett Gilliam.)

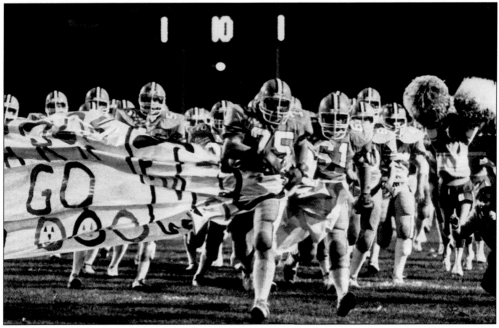

VIKINGS. Powell Valley High School has a strong tradition of academics, arts, and athletics. The Vikings' football team has won eight state football championships; seven were under 25-year-veteran coach and athletic director Phil Robbins. The Vikings have also won state championships in golf, basketball, and baseball. (Photograph courtesy of Garnett Gilliam.)

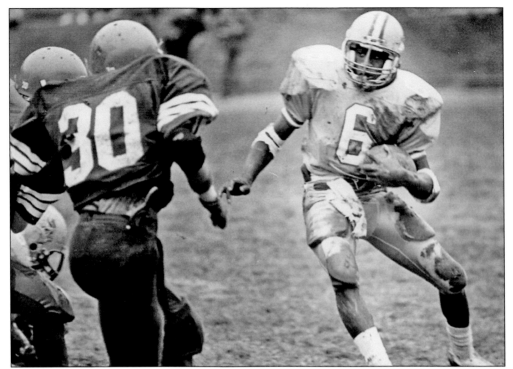

**THOMAS JONES AT POWELL VALLEY.** Jones set numerous state records, including most rushing yards in a season and most scoring in a career. He was the University of Virginia Cavaliers' all-time rushing leader. Professionally, he has played at running back for the Arizona Cardinals, Tampa Bay Buccaneers, Chicago Bears, and the New York Jets. (Photograph courtesy of Southwest Virginia Museum.)

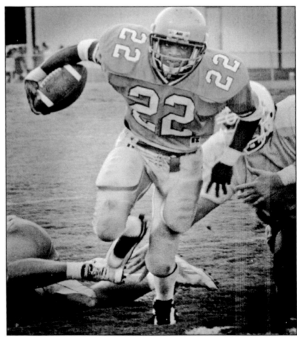

**JULIUS JONES.** After playing for Notre Dame, running back Julius Jones was drafted by the Dallas Cowboys in 2004. That same year, in a Thanksgiving Day game against the Chicago Bears and his brother Thomas, Julius was named player of the game for rushing 150 yards and making two touchdowns. In 2006, the brothers made NFL history as the first brother pair to rush 1,000 yards in the same season. (Photograph courtesy of Southwest Virginia Museum.)

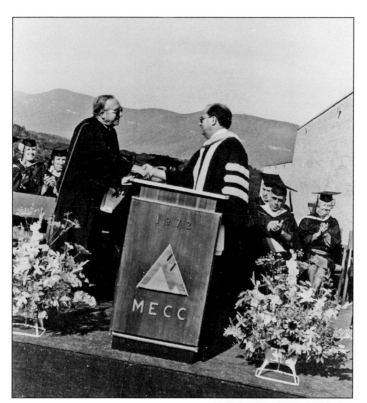

**MOUNTAIN EMPIRE COMMUNITY COLLEGE.** The college's groundbreaking was held in October 1971 with Dr. George B. Vaughan as the first president. The first classes were held in 1972. Successive college presidents have included Dr. Victor Ficker, Dr. Ruth Smith, Dr. Robert Sandel, and Dr. Terry Suarez. Holton Hall was the first building and was named after Gov. Linwood Holton, a Big Stone Gap native. (Photograph courtesy of Garnett Gilliam.)

**HOME CRAFT DAYS.** Since 1972, this festival has celebrated the traditional crafts and music of Southwest Virginia. Since the college's inception, the faculty has recognized the importance of preserving the area's rich culture. Roddy Moore, George Reynolds, and Sue Ella Boatright Wells were instrumental in starting and continuing the traditions of Home Craft Days. The festival is one of the many community programs created by the college. (Photograph courtesy of Garnett Gilliam.)

# Five

# IT'S YOUR CIVIC DUTY

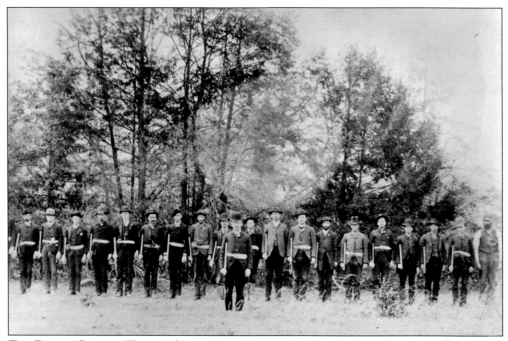

**THE POLICE GUARD.** The guard was organized in 1889 to bring the lawlessness under control. Its first captain was Joshua Bullitt. Pictured from left to right are Horace Fox (partially visible), Will Goodloe, Gordon Gilley, unidentified, J. A. Youell, unidentified, Nat Davidson, W. S. Beverly, H. A. W. Skeen, J. F. Bullitt, unidentified, W. S. Palmer, Dr. George Gilmer, J. N. Jones, D. Shelby, Bent Kilbourne, J. F. Jones, Bob Flanary, William Kennedy, Joshua Mullins, and unidentified. (Photograph courtesy of Southwest Virginia Museum.)

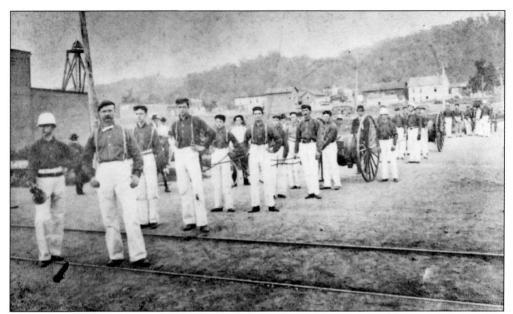

**FIRE BRIGADE.** Originally called the Powell's River Fire Brigade, it was organized in the 1880s and was reorganized in 1892. Early disastrous fires occurred in 1893, 1895, and 1908. A large bell was rung to alert fireman and citizens. The bell is still on display at the fire hall. The man in the front right of the photograph is W. S. Rose. (Photograph courtesy of Southwest Virginia Museum.)

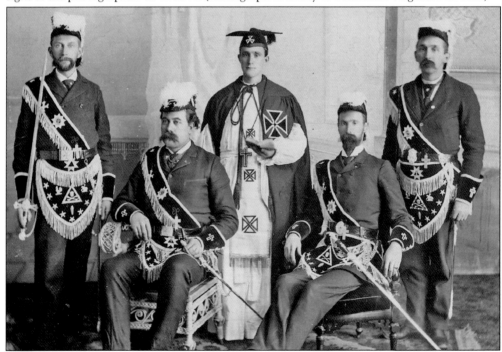

**KNIGHTS OF THE TEMPLAR.** Shown is the Knights Templar Commandary of 1892–1893. Pictured from left to right are W. C. Robinson, businessman; Charlie Evans; Rev. J. O. Straley, pastor of the Methodist church; W. S. Mathews, judge; William Kennedy, superintendent of schools. (Photograph courtesy of Southwest Virginia Museum.)

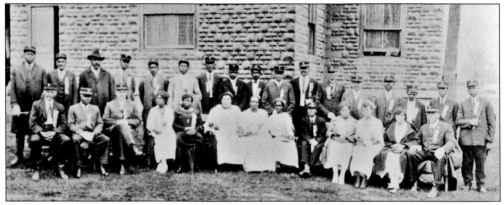

FRATERNAL ORDER, C. 1918. Henry Martin is the gentleman in the first row, third from the left. This photograph depicts a fraternal or church organization of which Martin was a member. (Photograph courtesy of Southwest Virginia Museum.)

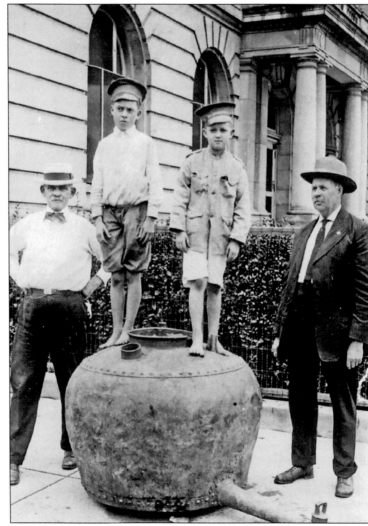

STILL CONFISCATION. Officials made numerous raids in and around the town and in Wise County. In one raid in 1936, a 300-gallon steamer was confiscated, and more than 2,800 gallons of mash were destroyed. In 1916, George Jones from the Revenue Bureau of the Treasury Department seized this still on Powell Mountain. Posing with the still in front of the courthouse are, from left to right, Jack Goodloe, John Long, Claude Jones, and revenue officer George Jones. (Photograph courtesy of Southwest Virginia Museum.)

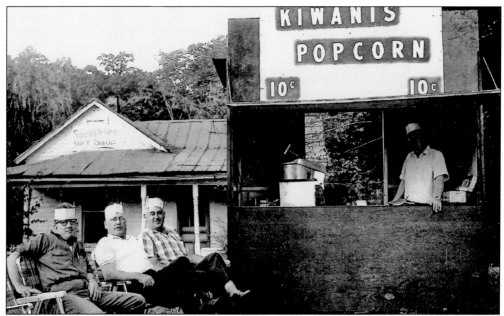

**KIWANIS CLUB.** Chartered in 1923, John Chalkey was elected the club's first president. Other officers included R. E. Taggart, vice president; A. L. Witt, secretary; J. B. Wampler, treasurer; and Dr. Karl Stoehr, officer. The club's first luncheon meeting was held at the Monte Vista Hotel. In the 1960s, the Kiwanis Club began selling popcorn at the Trail of the Lonesome Pine Outdoor Drama for a fund-raising project. (Photograph courtesy of Kiwanis Club.)

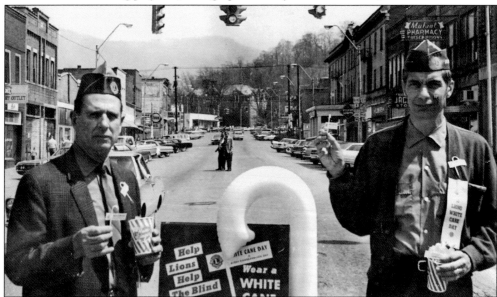

**LIONS CLUB.** The club was charted in 1951. The officers were Harry Metcalf, president; E. R. Daugherty, first vice president; Frank Mooneyhun, second vice president; Cecil Robinette, third vice president; Paul Quillen, secretary/treasurer; Clarence Johnson, tail twister; and Howard Broadwater, lion tamer. The White Cane fund-raisers are used to collect monies for their eye/vision program. Lions V. F. Jackson (left) and Jay Fred Tate participate in a White Cane Day. (Photograph courtesy of Garnett Gilliam.)

**JANIE SLEMP NEWMAN.** Along with her brother, C. Bascom, Janie Slemp was an enthusiastic historian. She kept journals and scrapbooks of regional happenings and was avidly involved in collecting the items that would later become the core collection of the Southwest Virginia Museum. Janie was active in many civic endeavors, including the Daughters of the American Revolution (DAR), where she served as historian. (Photograph courtesy of Southwest Virginia Museum.)

**DAR CEREMONY.** Here are members of the Daughters of American Revolution at the Janie Slemp Newman memorial. Members present included Julie McCorkle Rogers, Mrs. M. R. McCorkle, Mrs. Malcom Smith, Mrs. Roor, Mrs. J. L. McCormick, Mrs. E. J. Prescott, Mrs. Chas Gillispie, Mrs. R. H. Fink, Mrs. F. B. Kline, Mrs. S. M. Saunders, Mrs. J. J Hyatt, Mrs. E. A. Complori, and Mrs. Gilbert Knight. Also present is C. Bascom Slemp. (Photograph courtesy of the Southwest Virginia Museum.)

**CCC Camp, c. 1930s.** The Civilian Conservation Corp (CCC) known as Camp John Fox Jr. was located in the East Second Avenue area. M. S. Quesenberry Sr., P. A. Walker, and others assisted B. S. Gillespie, superintendent. The men were paid $1 per day, part of which was sent home, and were given room and board. They built roads, structures in the national forests, and other public works projects. (Photograph courtesy of Garnett Gilliam.)

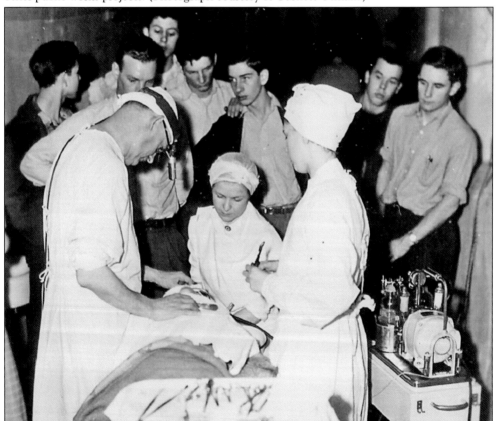

**Tonsillectomy, 1949.** The Kiwanis Club held a tonsil clinic for school children. Surgeries were performed on cafeteria tables set up in the gym. Dr. Charlie Henderson, assisted by local nurses, is performing this operation. Other doctors were Dr. G. E. Sutherland and Dr. L. E. Ball. Some of the onlookers include Bob Buckles, Eugene Mullins, John David Revella, Shang Bentley, Eddie Salyers, and Joe Rush. (Photograph courtesy of Garnett Gilliam.)

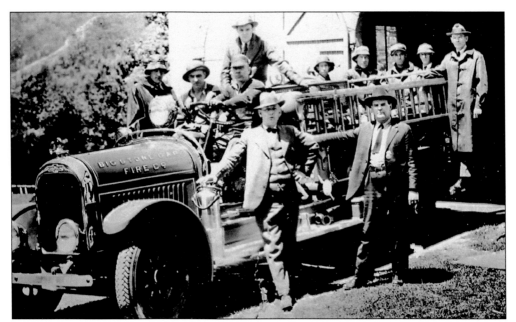

FIRE DEPARTMENT, C. 1927. Members pose with modern equipment. Standing beside the truck is fire chief Isaac Taylor (left) and police chief Hugh Boyd. In the cab, from left to right, are Suds Pannell, Gilmer Potter, and driver F. A. Baker. On top is Bob Daughtery. Located on the back of the truck are, from left to right, three unidentified, W. I. Nickles, and Brainard Masters. (Photograph courtesy of Garnett Gilliam.)

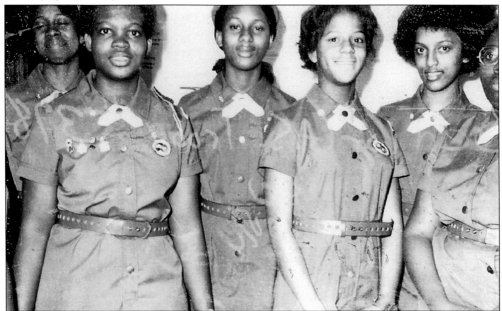

GIRL SCOUTS. The town had early, active African American Girl Scout troops. Community leaders such as Grace Warren sold pies to raise money for the Girl Scout hut that was then built on land donated by the Warren family. Charles Morris and Foster Fuller built the hut. Today the Girl Scout hut is owned and operated for girls in the Appalachian Girl Scout Council. (Photograph courtesy of Garnett Gilliam.)

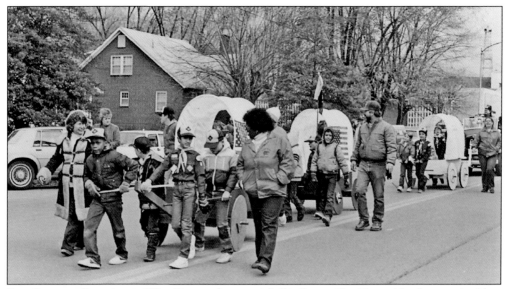

BOY SCOUTS. Scouting in Wise County began with Big Stone Gap Troop No. 3, organized less than a year after the national organization was started in 1910. In the 1930s, there was a strong effort to organize scouts in the other Richmond District towns and coal camps. This resulted in several new troops that were led by the superintendents of the camps. (Photograph courtesy of Garnett Gilliam.)

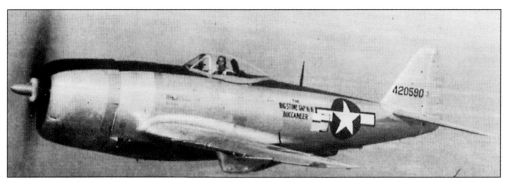

BUCCANEERS ROAM SKIES OF EUROPE, C. 1944. Wise County was active in the war bonds drives. The fifth war loan drive named three Thunderbolt planes after local mascots: the Buccaneers, the Tigers, and the Bulldogs. Aviation test pilot Fillmore Gilmer spearheaded these projects through the Republic Aviation Corporation. Previous war bond drives resulted in airplanes named after the Big Stone Gap, Appalachia, and Stonega Collieries. (Photograph courtesy of Garnett Gilliam.)

**WAC LaRue Bobich.** The army sent special recruiting teams to the town in 1944 to enlist women for the Women's Army Corps (WAC). LaRue Caudill Bobich spent the first part of World War II working as a third-class welder at the Norfolk Naval Base. She then enlisted in WAC and became a truck driver with the rank of corporal. (Photograph courtesy of Southwest Virginia Museum.)

**Welcome Home.** Francis Gary Powers, the U-2 pilot, was shot down over the Soviet Union in 1960, and the KGB sentenced Powers to 10 years of imprisonment and hard labor. He was traded for a Soviet spy in February 1962. Wise county residents, Powers and his parents were welcomed home at the Big Stone Gap Armory on March 12, 1962. (Photograph courtesy of Southwest Virginia Museum.)

**DECORATION DAY.** Memorial Day is a day of remembrance for those who have died in our nation's service. It is an important day each year at the town's cemeteries, Glencoe and Oakview. This Decoration Day ceremony is being held at Glencoe Cemetery, which was started in 1894 at the suggestion of the Reverend J. O. Straley. By 1896, twenty-five people had been buried there. (Photograph courtesy of Garnett Gilliam.)

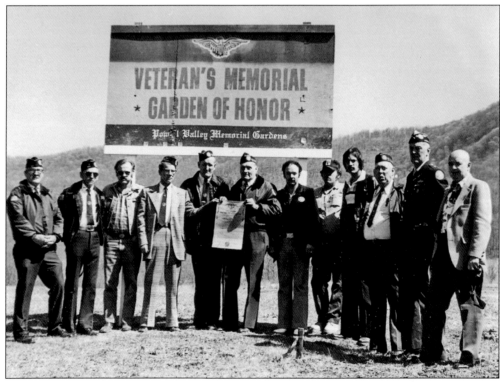

**POWELL VALLEY MEMORIAL GARDENS.** In this cemetery fly the flags of branches of the armed services. A special monument is "In Memory of All American Veterans." It reads, "This memorial honors all American veterans who, although separated by generations, shared a common, undeniable goal—to valiantly protect our country's freedoms . . . The American Veteran—forever a symbol of heroism, sacrifice, loyalty, and freedom." (Photograph courtesy of Garnett Gilliam.)

**DEVELOPING A HOSPITAL.** In the 1960s, the need for a hospital at Big Stone Gap was widely recognized, and the community rallied to make it happen. An intense fund-raising campaign was launched. Shown from left to right are J. R. Davidson, unidentified, Roy Brummitt Jr., and Barney Gilley. (Photograph courtesy of Garnett Gilliam.)

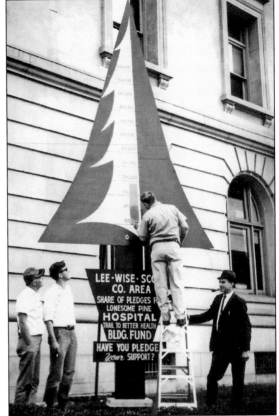

**BOARD OF DIRECTORS.** Members of one of the early hospital boards are pictured here. From left to right are as follows: (first row) Dr. Larry Fleenor, Tom Lobiondo, Ben Wheless, and James Kelley; (second row) Dr. Brownie Polly, Jim Cornett, and Charles Morris. (Photograph courtesy of Garnett Gilliam.)

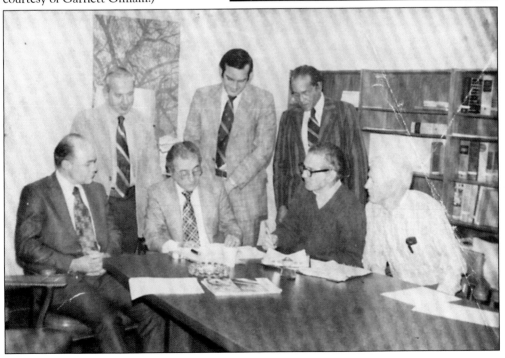

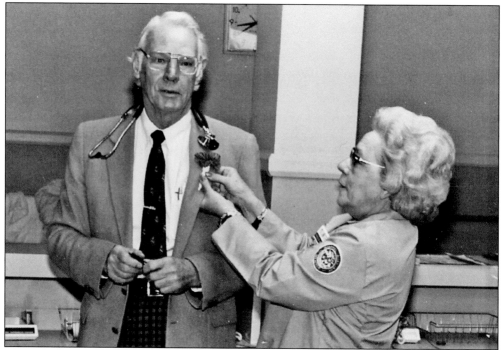

**Dr. Sutherland.** The modern hospital brought better services and more doctors to the area. Pictured here are Dr. George Sutherland and Evelyn Marrs, a member of the hospital auxiliary. Early doctors included physicians: Dr. Jeremiah Wells, Dr. J. A., Gilmer and W. A. Baker; Dr. J. W. Kelly, a physician and druggist; and dentists G. C. Honeycutt, C. E. Grear, F. A. Sproles, D. F. Orr, and B. E. Polly Jr. (Photograph courtesy of Garnett Gilliam.)

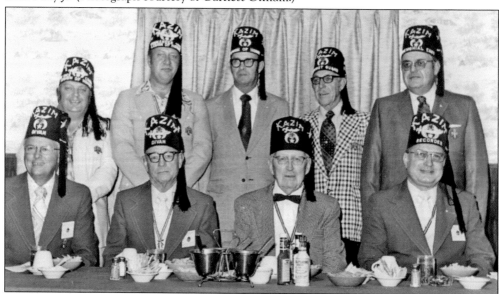

**Shriners.** The Powell Valley Shrine Club was chartered in 1956. The territory of the shrine included Lee County and Wise County west of Norton. Initial officers of the group were president Clifford Smith; vice presidents Dr. T. S. Ely, E. H. Mathis, and Ed Stewart; secretary Chester Luke; and treasurer J. H. Collier. (Photograph courtesy of Garnett Gilliam.)

**CROSS.** Young men help place the lighted cross on Imboden Hill. The project was initiated and funded by community leader Don Wax. The cross was just one of many projects to which he contributed during his lifetime. (Photograph courtesy of Garnett Gilliam.)

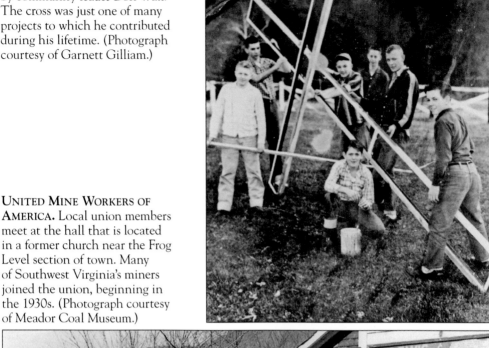

**UNITED MINE WORKERS OF AMERICA.** Local union members meet at the hall that is located in a former church near the Frog Level section of town. Many of Southwest Virginia's miners joined the union, beginning in the 1930s. (Photograph courtesy of Meador Coal Museum.)

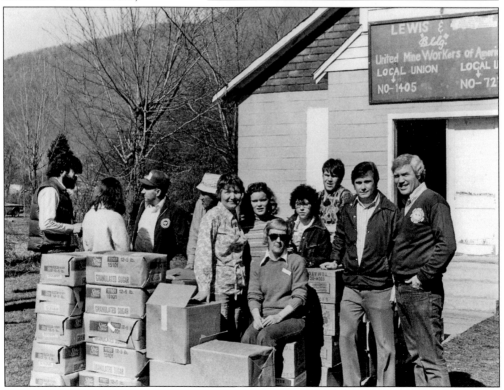

**BIRTH OF THE RESCUE SQUAD BUILDING.** The rescue squad was organized in 1962, and the building was constructed in 1964. Glenwood King donated the land for the building, and the volunteers pictured here donated the labor. (Photograph courtesy of Garnett Gilliam.)

**LINWOOD HOLTON.** Born in 1923, Holton attended Harvard Law School and became an attorney. He was deeply involved in Republican politics in the 1950s and 1960s. Holton was elected governor of Virginia in 1969 and served from 1970 to 1974. He was Virginia's first Republican governor since 1884. As governor, Holton championed equality and increased employment and appointments for African Americans and women in government. (Photograph courtesy of Garnett Gilliam.)

# *Six*

# A GOOD TIME
# WAS HAD BY ALL

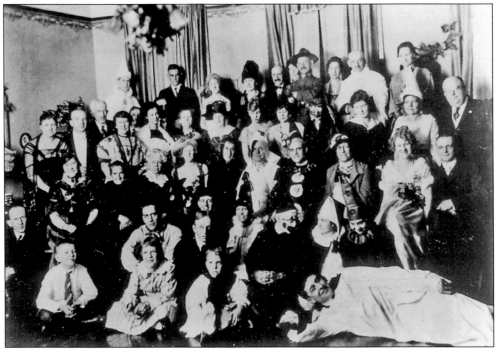

**HALLOWEEN PARTY, 1900s.** Early citizens' calendars were filled with social functions. Germans, or early dances, were common. Other events included card parties, concerts, and ice cream socials. Citizens in attendance at this party included H. E. Fox, Willard Miller, E. J. Prescott, H. L. Miller, and Julia and James Ayers. John Fox Jr. is also in attendance at this Halloween Party. Can you find him? (Photograph courtesy of Southwest Virginia Museum.)

**BULLITT PARK FOOTBRIDGE, C. 1890.** The bridge was used by the Mountain Golf Club to access greens on both sides of the river and to access the park's baseball field. The bridge was destroyed in 1931 and was replaced with a swinging bridge. In 1959, during the Singing Convention, a cable pulled loose and tumbled 10 people off the bridge, killing one. (Stereocard courtesy of C. F. and Debbie Wright.)

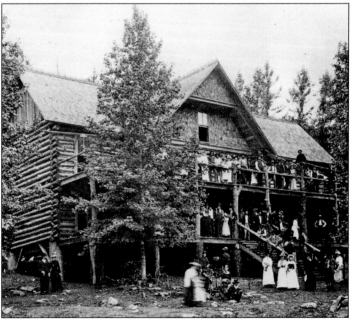

**MOUNTAIN PARK ASSOCIATION, 1890s.** A development plan was to purchase High Knob and the surrounding land to form a game preserve. The Dummy Line would connect the park to town. A Swiss-style clubhouse was planned as a tourist resort. Records do not indicate that this structure materialized; this building might be a structure built on High Knob by Patrick Hagan and Rufus Ayers. (Photograph courtesy of Garnett Gilliam.)

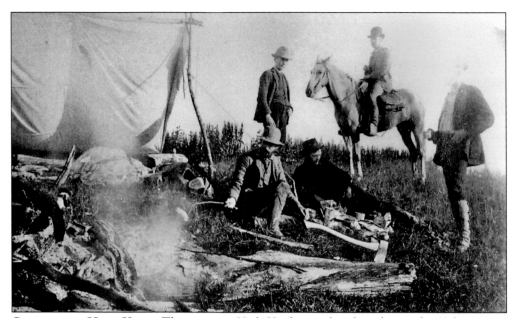

**CAMPING ON HIGH KNOB.** The game on High Knob was abundant during the 19th century, particularly black bear, deer, and turkey. The plan for the 3,000-acre game preserve was to enclose it with a high fence and stock it with game of all kinds. The goal was to create one of the finest shooting parks in America, with gamekeepers and enforced laws. (Photograph courtesy of Garnett Gilliam.)

**HUFF ROCK.** Huff Rock has been a popular gathering place for generations. The rock is named for a Civil War deserter called Huff who hid and lived there during the war. A woman was said to have lived at the rock with him. He was found and shot for desertion. The natural rock house used by Huff is still used by many campers. (Photograph courtesy of Southwest Virginia Museum.)

**BULLITT PARK BASEBALL FIELD.** The Big Stone Gap Athletic Association was formed in 1897. They sponsored a baseball team and helped build the ball field at the park. From 1949 to 1953, the Rebels, a professional baseball team, played at Bullitt Park as part of the Mountain States League. These players were signed by major league teams and were then signed out to the Rebels. (Postcard courtesy of C. F. and Debbie Wright.)

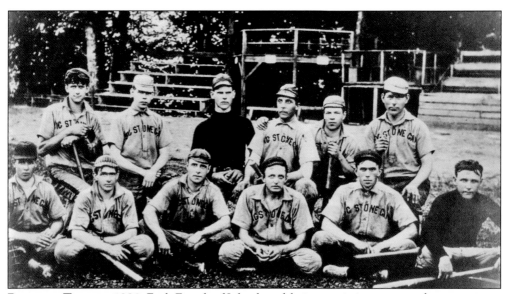

**BASEBALL TEAM, C. 1890.** Each Fourth of July, the athletic association sponsored a tournament with area baseball clubs. Pictured from left to right are the following players: (first row) T. Goodloe, Ed Taylor, Ted Wentz, John Fox Jr., B. Durritt, and H. McCabe; (second row) H. Hogue, H. Barr, G. B. Taylor, Will Slemp, B. Cardin, and D. Mullins. (Photograph courtesy of Garnett Gilliam.)

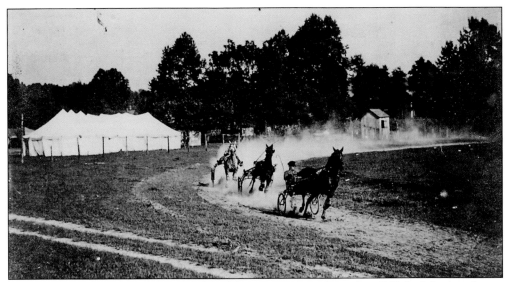

**BULLITT PARK HARNESS RACING.** The athletic association, formed in 1897, laid the foundation for Bullitt Park. The association sponsored many early events, including the large Fourth of July events. Horse racing was one of the most frequent events. The need for better facilities led to the contract for building a fence and grading a racetrack in May 1906. (Photograph courtesy of Garnett Gilliam.)

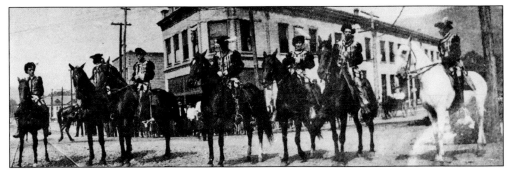

**KNIGHTS OF THE TOURNAMENT, 1911.** Jousting tournaments were held on the Fourth of July. Men wore costumes and rode under a *nom de guerre* such as the Knight of the Cumberland, Wallens Ridge, and others. Those on horseback are J. H. McLemore, J. M. Goodloe, H. J. Ayers, W. G. Painter, J. K. Taggart, J. F. Bullitt Jr., and A. K. Morrison. (Photograph courtesy of Southwest Virginia Museum.)

FOX CHASE. These were drag hunts, during which the fox was killed prior to the chase. The 1904 chase rules included, "All home dogs, not in the chase, must be tied up until 12 noon, on the Fourth. All loose dogs, not hounds, will be shot by order of the town council. It is absolutely necessary that the hounds have a free course-one cur dog may spoil the whole chase." (Photograph courtesy of Garnett Gilliam.)

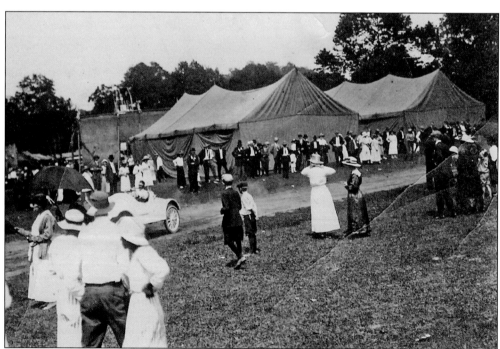

CAR RACING. Automobile exhibition races were also popular on the Fourth of July. Other activities included balloon ascensions, pistol target matches for the police guard, horse shows and races, mule races, tennis matches, and all types of field sports. These Fourth of July events attracted around 10,000 people in 1907. (Photograph courtesy of Garnett Gilliam.)

102

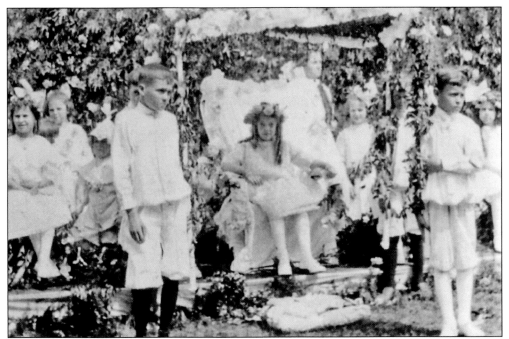

MAY DAY QUEEN, 1913. May Day is May 1st and is a celebration of springtime. A common Victorian-era gathering, May Day rites often included a maypole, dancing, and the crowning of a queen. This May Day queen was crowned at festivities held at Bullitt Park. (Photograph courtesy of Southwest Virginia Museum.)

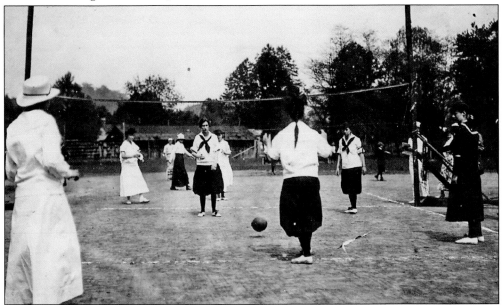

BULLITT PARK VOLLEYBALL. The park's concrete stadium was named the H. E. Fox Memorial Stadium; the park itself remained unnamed until 1935. The town council, in cooperation with the *Post*, held a contest to name the park. The prize was $5 for the person who submitted the chosen name. The park was named Bullitt after attorney and police guard captain Joshua Bullitt. (Photograph courtesy of Garnett Gilliam.)

LONESOME PINE COUNTRY CLUB. Depicted is the first membership meeting of the country club in April 1924. The club had 111 charter members. Creed Blanton was instrumental in securing the property and choosing the clubhouse site. Club charter members held Saturday workdays to clear the ground to develop the greens. (Photograph courtesy of Garnett Gilliam.)

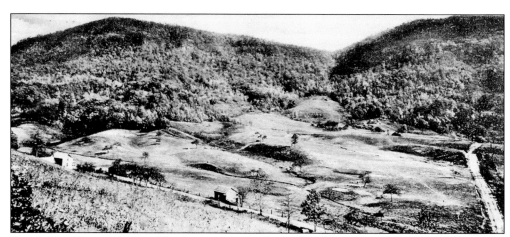

BIRD'S-EYE VIEW OF LINKS. The first round of golf was played on July 4, 1923. Only two fairways, the first and second, and three greens were ready. The fairways were about 20 yards wide, and the rough on either side was more than 20 inches tall. Bob Graham suggested the name Lonesome Pine Country Club after John Fox Jr.'s book that had been written 15 years earlier. (Postcard courtesy of C. F. and Debbie Wright.)

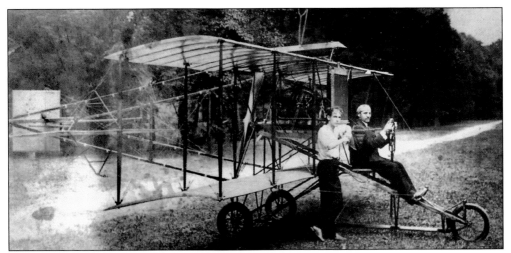

**FIRST AIRPLANE.** In 1923, W. H. Wren and Capt. William Duff landed the first airplane on present-day Aviation Road. Duff had given Wren flying lessons and had recently purchased the Avro airplane in New York. This flight began the continued use of the Aviation Road area as a center of flight in Big Stone Gap. (Photograph courtesy of Garnett Gilliam.)

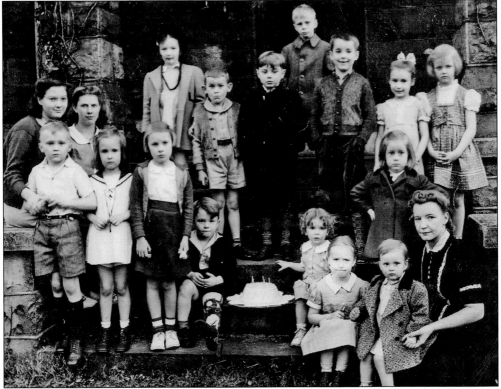

**BIRTHDAY PARTY AT EDMONDS' RESIDENCE.** Shown to the left of the cake are Cammie Edmonds, unidentified, Elaine Rankin, John Boston, Pearl Olinger, Minerva Olinger, Martha Jane Powers, and Danny True. Shown to the right of the cake are Nancy Edmonds, Cathy Renshaw, Betty Jane Slemp, Rhea Slemp, unidentified, Peggy Jo Wilson, and Harriet Holton. In the center stands John Bradburn, Dane Stone, and Bobby True. (Photograph courtesy of Southwest Virginia Museum.)

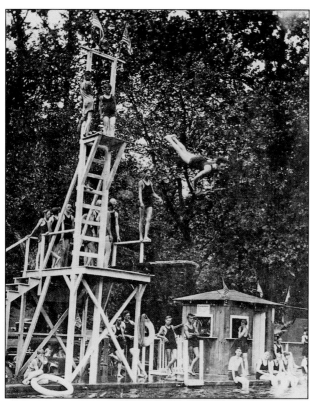

**PLEASURE ISLAND.** Opened in 1925 by Jim Taylor, Pleasure Island featured a swimming pool, concession stand, and portable skating rink. A contest was won by Dr. W. A. Baker to name the new swimming facility. For his efforts, Dr. Baker received a season ticket to the pool. (Photograph courtesy of Garnett Gilliam.)

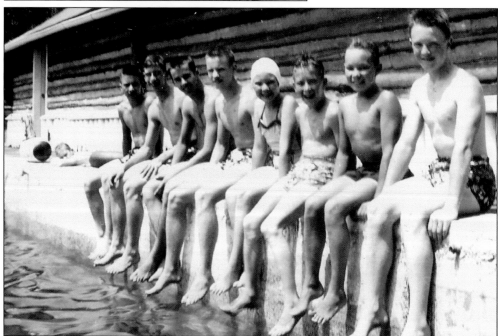

**SWIMMING CLASS, C. 1952.** Many kids learned to swim at the Pleasure Island pool. Pictured from left to right are Bob Daughtery, Eddie Saylers, Bobby True, Phillip Kinder, Nancey Edmonds, Phillip Gilliam, Johnny Mahaffey, and Cammie Edmonds. (Photograph courtesy of Garnett Gilliam.)

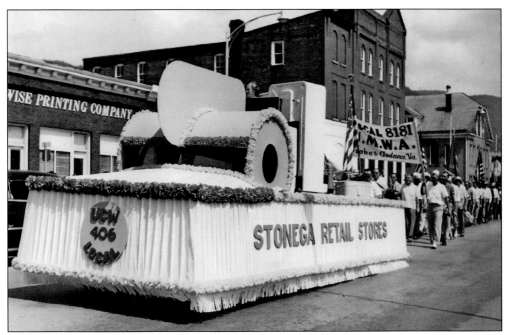

LABOR DAY, 1956. The United Mine Workers of America (UMWA) chose the town for its Labor Day parade. District No. 28 held a huge celebration with a parade of union locals, pensioners, bands, and floats. Carson Hibbitts, president of District No. 28, introduced other UMWA speakers: William Mitch, Bedford Bird, Archie Woods, and M. W. Clark. Mayor J. E. Body Sr. and congressman Pat Jennings also spoke at the event. (Photograph courtesy of Meador Coal Museum.)

BULLITT PARK TRAPEZE ACT, 1956. After the parade, entertainment was held at Bullitt Park. A prize of $100 was awarded to the union local having the largest percentage of members present. An estimated 18,000 participants jammed the town for Jimmy Hetzer's big stage review, the crowning of Miss UMWA, and the finale aerial act. (Photograph courtesy of Brenda Smith.)

RIM ROCK. Located atop Stone Mountain, Rim Rock Railroad and Recreation Area operated from 1968 to 1974. It featured a two-mile, narrow-gauge railroad and steam engine. The train transported passengers to the observation point, Rim Rock. From there, visitors could overlook beautiful Powell Valley and the mountains beyond. The 950-acre area also featured a model frontier town, picnic and camping areas, and a five-acre lake. (Photograph courtesy of Garnett Gilliam.)

POWELL VALLEY SKATING RINK. Girl Scouts are lining up to get their skates. The skating rink was part of the Valley Lake recreational facilities. Several small springs were dammed to form the lake. Visitors could enjoy picnicking and swimming. The Bloomer family built and operated Valley Lake and the skating rink. (Photograph courtesy of the C. F. and Debbie Wright.)

# Seven

# A LITTLE TOWN WITH A BIG STORY

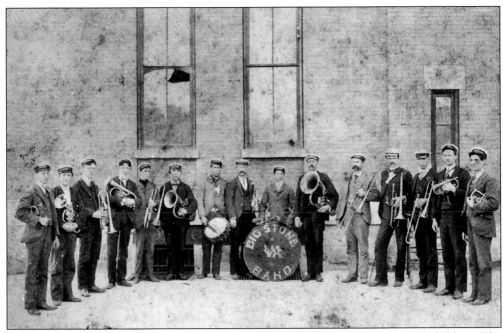

**BRASS BAND, 1909.** The town was filled with diversions for men, women, and children. The brass band played at local events and traveled throughout the region. Pictured from left to right are Emmet Nickels, Isaac Taylor, William Jessie, Will Carnes, Ed Taylor, Theo Brown, Jack Cox, unidentified, William Nickels, Bob Slinzer, W. S. Rose, Dr. T. A. Sproles, Walter Burn, Frank Witt, and Guy Taylor. (Photograph courtesy of Southwest Virginia Museum.)

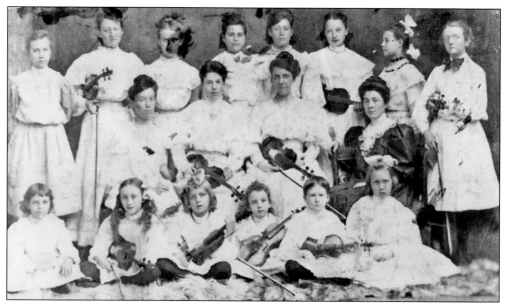

MUSIC GROUP. The first music club was organized in 1895. In the early 1900s, there were two schools that taught vocal and instruments, the Highland Technical Institute and the Southwest Conservatory of Music. Two of the girls pictured here are Virginia Beverly (McChesney), the band director; and Hallie Litton, who later instructed pianist Larry Dalton. (Photograph courtesy of Southwest Virginia Museum.)

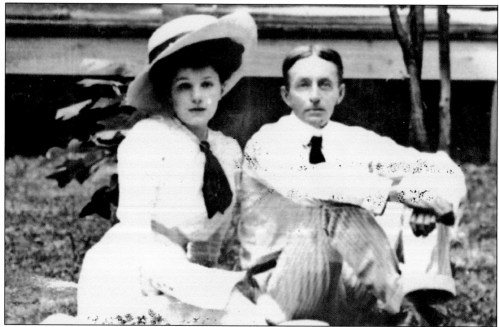

JOHN FOX JR. AND FRITZI SCHEFF. The author married the opera star in 1908; both were national figures. She arrived in the town with numerous trunks, five maids, and a dog. Fritzi often entertained family, friends, and neighbors with her beautiful singing at the Fox family home; however, the star could not adjust to John's simpler lifestyle in "The Gap." The couple soon divorced. (Photograph courtesy of Garnett Gilliam.)

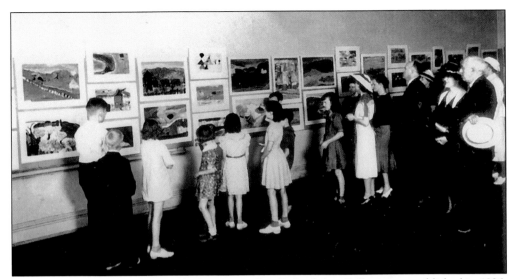

**WPA ART GALLERY, C. 1930.** The Big Stone Gap Federal Art Gallery was established in 1936. It was the first WPA art gallery in Virginia. Located on the third floor of the elementary school, exhibits featured local and national artists. Both adults and children received art instruction in the many classes taught at the gallery. (Photograph courtesy of Southwest Virginia Museum.)

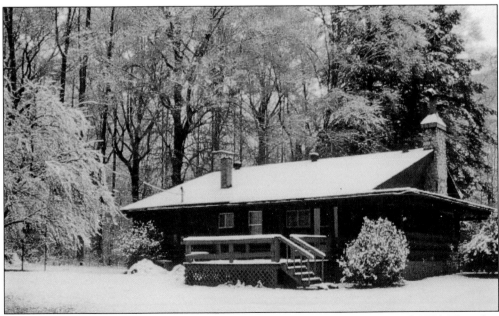

**WPA LOG CABIN.** Another WPA program was the National Youth Association (NYA). The cabin was built by the NYA's young men and was partially financed by the women's domestic training program. A partnership with Girl Scouts who needed a place to train leaders and meet troops led to the building's construction in 1939. The cabin is a state landmark and on the National Register of Historic Places. (Photograph courtesy of Marilyn Bumgardner.)

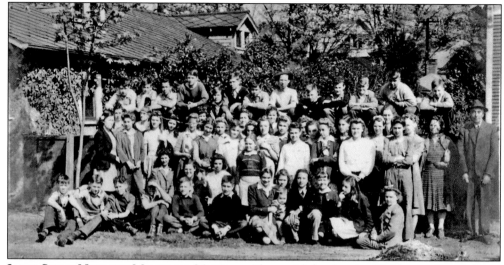

**JANIE SLEMP NEWMAN MEMORIAL MUSEUM.** Along with her brother C. Bascom Slemp, Janie collected historical items from Southwest Virginia. Congressman Slemp operated this museum in a garage behind his house on West Second Street. He is shown here with children on a field trip to the museum. Slemp bequeathed the museum's collection to the Commonwealth of Virginia to start the Southwest Virginia Museum. (Photograph courtesy of Southwest Virginia Museum.)

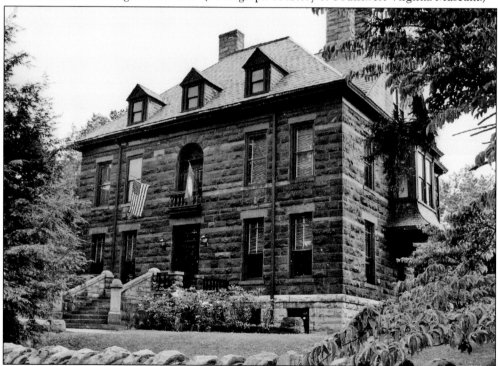

**SOUTHWEST VIRGINIA MUSEUM.** Formerly the Ayers Mansion, the building that houses the Southwest Virginia Museum was purchased by C. Bascom Slemp in 1929. For a number of years, relatives lived in the home. After his death in 1943, the property was acquired by the Virginia State Park system in 1946, and the museum opened in 1948. (Photograph courtesy of Southwest Virginia Museum.)

**JAMES TRUE.** In 1938, True came to Big Stone Gap to teach and exhibit at the WPA Art Galley. He also became Slemp's artist-in-residence and began painting and building dioramas for the Janie Slemp Memorial Museum. When the state established a Southwest Virginia Museum, True was hired as the first curator. (Photograph courtesy of Southwest Virginia Museum.)

**MEADOR COAL MUSEUM.** Built by John Fox, the structure housed a mineral museum and offices. In the 1920s, the Kiwanis Club purchased it for a meeting place. In the 1940s, it was deeded to the Community League, becoming the site of many parties, dances, and meetings. In 1982, it became the Meador Coal Museum. Harry Meador was vice president of eastern operations for Westmoreland Coal Company. (Photograph courtesy of Meador Coal Museum.)

113

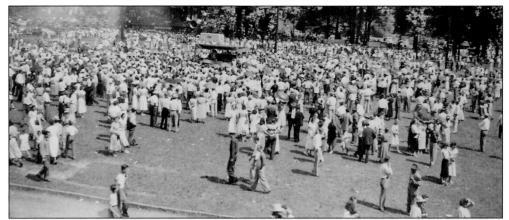

**SINGING CONVENTION.** Held every second Sunday in June since 1921, the Singing Convention was started by C. W. Wadell. Early organizers included Sam Sproles, Levi Jones, Harrison Fleenor, John Williams, and Guy Stone. Rev. Sylvan Wilson organized it during the 1940s. The Reverend Paul Miller and Sylvan Wilson's descendents carried on the tradition in the 1970s and 1980s. The Gardner family later planned the event. (Photograph courtesy of C. F. and Debbie Wright.)

**JUNE TOLLIVER HOUSE.** In 1963, the Tolliver House was opened as a crafts center. The 1888 structure was a boarding house owned by Mrs. Jerome Duff. In 1891, rates were $1 per day to the traveling public, with special terms for monthly boarding. Elizabeth Morris, a young mountain girl, boarded here and attended school. Elizabeth was the basis for John Fox Jr.'s character June Tolliver. (Photograph courtesy of Garnett Gilliam.)

**BURNING THE NOTE ON THE TOLLIVER HOUSE.** Lonesome Pine Arts and Crafts was established in 1963, first opening the Tolliver House and, shortly thereafter, staging the first performance of the outdoor drama. Today they also operate the Fox and the School Museums. Board members pictured from left to right are Dr. William Botts, John Fischer, Glessie Martin, Clara Lou Kelly, Jack McClanahan, and J. Lincoln Kiser. (Photograph courtesy of Garnett Gilliam.)

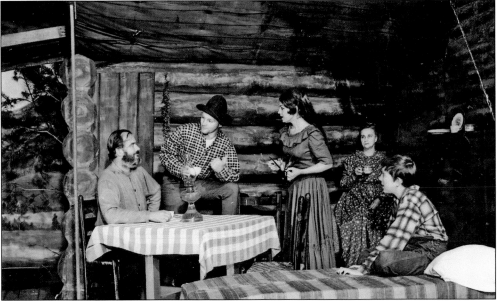

**TRAIL OF THE LONESOME PINE OUTDOOR DRAMA.** Based on John Fox Jr.'s book, the outdoor drama opened on August 15, 1964. During the first year, the cast gave nine performances. Pictured from left to right are Tommy Masters, Larry Hobbs, Barbara Polly, Mary Lile, and Joey Bailey. (Photograph courtesy of Garnett Gilliam.)

**DOGWOOD GARDEN CLUB.** The Dogwood Garden Club is posing at an early flower show at the Southwest Virginia Museum. Pictured from left to right are Betty Cline, Gladys Wade, Carrie Weatherly, Winifred Whitt, Faye Pobst, Ruth McClanahan, Louise Camblos, and Ann Hunter. (Photograph courtesy of Garnett Gilliam.)

**VALLEY GARDEN CLUB.** Here is the Valley Garden Club at a Christmas flower show at the June Tolliver House. Pictured from left to right are Eva George, Maude Dickenson, Hazel Donaldson, Martha Callahan, Ruth Dickenson, Betty Wentz Tate, Genese Poole, and Martha Hobbs. (Photograph courtesy of Garnett Gilliam.)

**INTERMONT GARDEN CLUB.** The Intermont Club poses with flower show ribbons at the John Fox Jr. home. Some of the members pictured here are Sandy Jessee, Karen Hall, Connie Cooper, and Thelma Carter. (Photograph courtesy of Garnett Gilliam.)

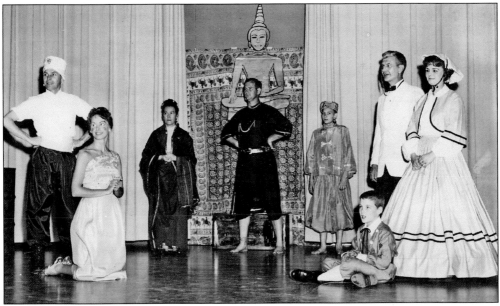

**THE KING AND I.** The Music Study Club began in 1921 and produced its first full-fledged musical in April 1963. *The King and I* was directed by Mrs. T. Reid Rankin and starred Tommy Masters as the king and Barbara Polly as Anna. Among those pictured are James Hensley, Judy Womack, Estelle Crockett, Harry Meador III, Albert Sandt, Barbara Polly, and Harold Hill, who is seated. (Photograph courtesy of Barbara Polly.)

COMMUNITY CONCERT. Founded in the 1970s, the community concert was organized to bring touring artists to Big Stone Gap. Pictured from left to right are the community concert's Columbia Artists booking agent (unidentified), Jack Gibbs, Larry Hobbs and his son, and Ida Trigiani. (Photograph courtesy of Garnett Gilliam.)

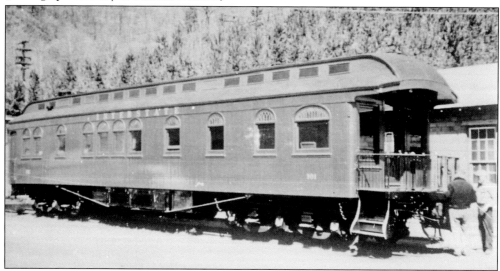

INTERSTATE RAILROAD CAR NO. 101. Built in 1891, the car served as the president's car of the Interstate Railroad. It had two bedrooms, a small living and dining room, and a galley with private porter. In 1988, the car was acquired by the Gap Corporation and is utilized as the town's tourist and information center. The car is restored and retains its original wood and brass. (Photograph courtesy of Garnett Gilliam.)

118

**MAGGARD SOUND.** Since 1963, the studio owned by Charlie and Alan Maggard has developed a reputation for gospel and bluegrass commercial recordings. In 2002, the studio recorded *Lost in the Lonesome Pines* by Jim Lauderdale and Ralph Stanley and the Clinch Mountain Boys, which was the Grammy-winning bluegrass album of the year. Many other artists have recorded there, including Jessee McReynolds, the Singing Cookes, and Blue Highway. (Photograph courtesy of Maggard Sound.)

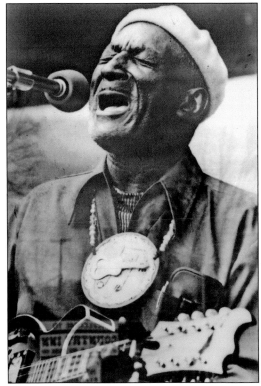

**CARL MARTIN.** Born in 1906, Martin's family moved to Knoxville when Carl was around age 12. Martin could play the mandolin, guitar, fiddle, and string base. Early in his career, he formed the band the Tennessee Chocolate Drops. Martin moved to Chicago, and in the 1960s, he joined with Brogan and Armstrong, two blues musicians, to play the folk and blues circuit throughout the country. (Photograph courtesy of Crooked Road kiosk.)

ROY HALL. Born James Faye Hall in 1922, Roy Hall was a rockabilly piano player in the 1950s. Hall is credited with writing the song, "Whole Lotta of Shakin' Goin' On," popularized by Jerry Lee Lewis. He played piano for music legends Webb Pierce and Marty Robbins. Hall (right) poses with Mel Tillis. Another Nashville-based musician from Big Stone Gap is Harold Hill. (Photograph courtesy of Southwest Virginia Museum.)

THE VIRGINIANS. Joe Flanary started this band in 1966. The group played a variety of music and was well known for its big band sound. The first Virginians were Joe Flanary, Merle Dockery, Danny Collier, Glenn Smith, Buddy Stewart, Ron Flanary, and Ron Swindall. Over the years, some members left and other joined, including musicians Mark Wooten and Dave Tipton. (Photograph courtesy of Ron Swindall.)

**DAVE TIPTON.** Tipton is pictured here with his high school band teacher, "Papa" Joe Smiddy. Tipton's earliest gig was in Smith Carson's band, playing in area nightclubs and dance halls as a teenager. He served as band director in Germany for the U.S. Army and at high schools in Lee and Wise Counties, with many years at Powell Valley High School. In retirement, he formed a jazz band: the Jerome Street Ramblers. (Photograph courtesy of Garnett Gilliam.)

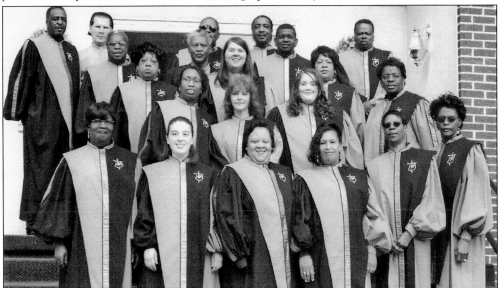

**EVANGELISTIC CHORALAIRES.** The oldest African American gospel group singing in Southwest Virginia, the Evangelistic Choralaires have been performing for more than 40 years. A few of the longtime members include Richard Lomax and Frank Gravely. Several of the female singers in the group are ordained ministers and daughters of coal miners. Other gospel singers with community roots include Harold Gilley, Rick Akens, and the Wilson Trio. Another popular choral group was the Southlanders. (Photograph courtesy of Frank Gravely.)

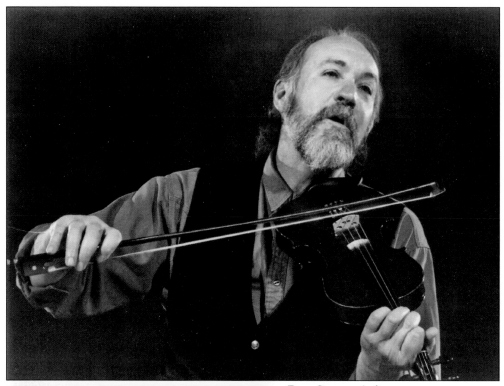

RON SHORT. A director, actor, playwright, composer, and musician, Short has contributed to the national dialogue on cross-cultural collaboration and has been a strong advocate for Appalachian culture. Over the period of 26 years, he has scripted and composed music for 15 plays, toured with Roadside Theater's productions, and produced numerous music recordings. (Photograph courtesy of Roadside Theater.)

LARRY DALTON. A producer, arranger, conductor, and soloist, Dalton began playing piano by ear at age three. He is a Steinway piano artist and has arranged concert, show music, and orchestral arrangements for artists Ellis Marsalis, Mel Torme, Henri Mancini, and many others. Larry cofounded Living Sound International, a musical ministry that gave concerts on five continents. He also served as music director for Oral Roberts television. (Photograph courtesy of LarryDalton.com.)

ROY C. SMITH. His tenor voice has been featured at the Metropolitan opera, Lyric Opera of Chicago, Volksoper Wien in Vienna, Satzburger Festspiele, and the New Israeli Opera. His honors include being the 1990 winner of the Metropolitan Opera National Council Auditions, the 1997 winner of the Licia Albanese/Puccini International Voice Competition, and the recipient of the Eleanor Steber Award from Baltimore Opera. Smith holds a doctorate of musical arts from the American Conservatory of Music (Photograph courtesy Model Image Center.)

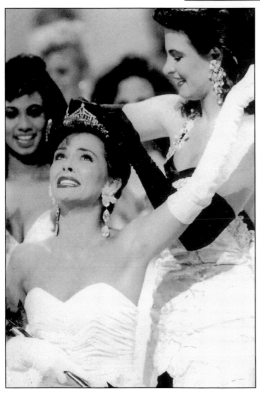

LEANZA CORNETT. Crowned Miss America in 1993, Leanza Cornett was born in 1971 in Big Stone Gap. Cornett later moved to Florida. During her reign, Leanza was the town's Christmas parade grand marshal, speaking out for aids prevention. Leanza became a television personality, hosting shows like *Entertainment Tonight*. Other television, movie, and stage performers with community roots include Debbie Strang, John Wilson, and Patrick Wilson. (Photograph courtesy of Shirley Rogers.)

**MONIQUE GIBSON.** A well-known, Atlanta-based designer, Gibson graduated from the University of Tennessee and the Art Institute of Atlanta. Her designs have been featured by *Architectural Digest*, *Atlanta Magazine*, and *Home and Garden Television*. Clients have included Jon Bon Jovi, John Mellencamp, and Elton John. (Photograph courtesy of Barbara Gibson.)

**ADRIANA TRIGIANI.** A playwright, television writer, and producer, Trigiani's many credits include *The Cosby Show* and *A Different World*. Her hometown was the setting for her debut novel, *Big Stone Gap*. Since 1999, the best-selling author has produced a new novel every year. Those in the *Big Stone Gap* series include *Big Cherry Hollow*, *Milk Glass Moon*, and *Home to Big Stone Gap*. (Photograph courtesy of Timothy Stephenson.)

**GEORGE DALTON.** A newspaper photographer and writer, Dalton took many of the mid- and late-20th-century photographs in this book. A family member referred to Dalton as "the Forrest Gump of Southwest Virginia, because he managed to be at all the important events." For several decades, Dalton was at every event, large and small, and chronicled the happenings of the community. (Photograph courtesy of Garnett Gilliam.)

**GEORGE JENKINS.** Southwest Virginia's premier photographer from the turn of the 19th century through the 1940s, Jenkins was most noted for his landscapes. The camera he used produced an 8-inch-by-20-inch negative, which produced 8-inch-by-20-inch photographs. It is through Jenkins's photography that the town's history can be understood. (Photograph courtesy of Garnett Gilliam.)

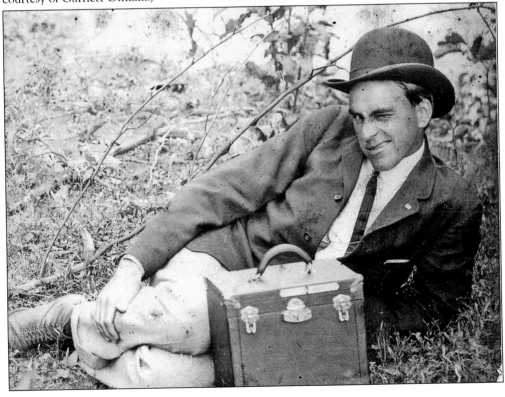

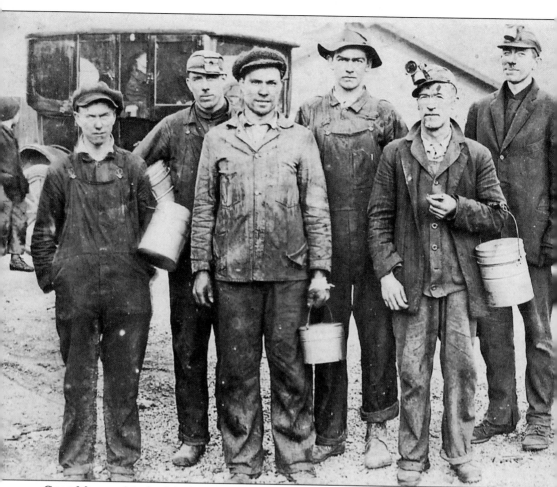

**COAL MINERS.** Much of the history of Big Stone Gap and Southwest Virginia is based upon the legacy of coal mining. It was the natural resources of these mountains that brought people to this region. It is community pride, family values, and natural beauty that bind people to this special place at the three forks of the Powell River. (Photograph courtesy of Meador Coal Museum.)

# BIBLIOGRAPHY

Cox, Eugene and Joyce. *Keokee, Virginia: Origins of an Appalachian Coal Mining Community.* Johnson City, TN: Keokee High School Alumni Association, 2007.

Fleenor, Larry. *The Bear Grass.* Big Stone Gap, VA: Big Stone Gap Publishing, 1991.

Hendrick, Bill. *Big Stone Gap: The Early Years.* Big Stone Gap, VA: Wise Printing Company, 1988.

Hendrick, Bill. *Westmoreland Coal Company: An Exciting Story.* Big Stone Gap, VA: Wise Printing Company, 1984.

Henson, Edward and Larry Lawson. *High Hopes to Highwalls: A Documentary History of Wise County.* Wise, VA: University of Virginia's College at Wise, 1973.

Historical Society of Southwest Virginia. *Historical Sketches of Southwest Virginia.* Publication Nos. 2, 5, 10, 14, and 23. Historical Society of Southwest Virginia, 1966–1989.

Lonesome Pine Office on Youth. *Looking Back: Wise County in the Early Years.* Big Stone Gap, VA: Lonesome Pine Office on Youth, 1992.

Prescott, E. J. *The Story of the Virginia Coal and Iron Company. 1882–1945,* Big Stone Gap, VA: Virginia Coal and Iron Company, 1945.

Rottenberg, Dan. *In the Kingdom of Coal: An American Family and the Rock That Changed the World.* New York: Routledge, 2003.

*The Post Newspaper.* Big Stone Gap, VA: Wise Printing Company, 1895–1970.

Wax, Don. *The Goodloes: A Journey through the Twentieth Century that Began in Big Stone Gap. VA in 1903,* Big Stone Gap, VA: Wise Printing Company, 2001.

# DISCOVER THOUSANDS OF LOCAL HISTORY BOOKS FEATURING MILLIONS OF VINTAGE IMAGES

Arcadia Publishing, the leading local history publisher in the United States, is committed to making history accessible and meaningful through publishing books that celebrate and preserve the heritage of America's people and places.

Find more books like this at
## www.arcadiapublishing.com

Search for your hometown history, your old stomping grounds, and even your favorite sports team.